Draw **50**
Monsters, Creeps, Superheroes, Demons, Dragons, Nerds, Dirts, Ghouls, Giants, Vampires, Zombies, and Other Curiosa...

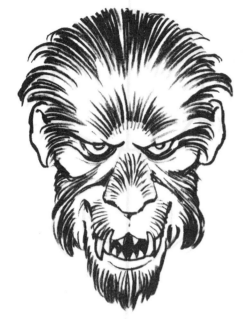

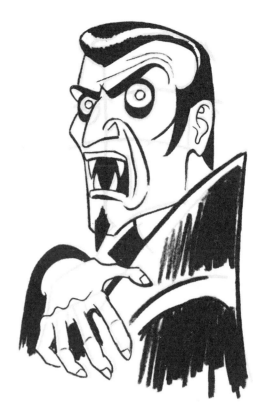

LEE J. AMES

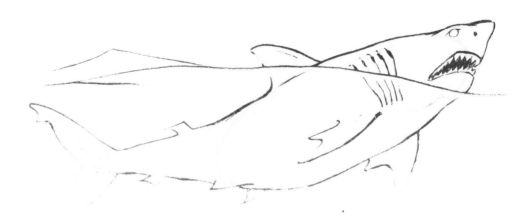

Draw 50
Monsters, Creeps, Superheroes, Demons, Dragons, Nerds, Dirts, Ghouls, Giants, Vampires, Zombies, and Other Curiosa...

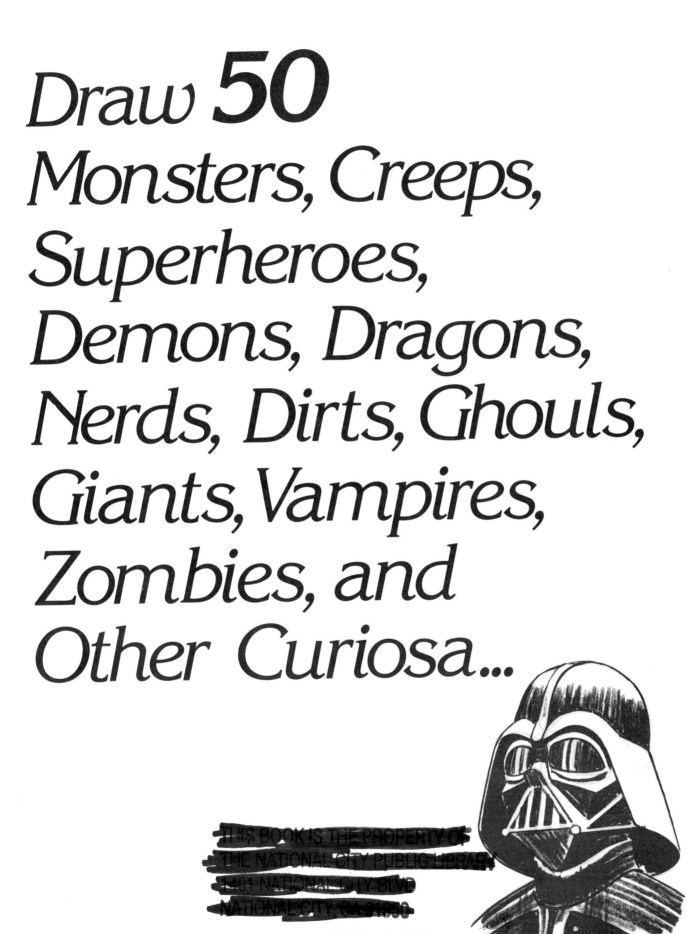

BROADWAY BOOKS
New York

BROADWAY

Published by Broadway Books
a division of Random House, Inc.

BROADWAY BOOKS and it's logo, a letter B bisected on the diagonal, are
trademarks of Broadway Books, a division of Random House, Inc.

ISBN: 0-385-17637-6 Trade
ISBN: 0-385-17638-4 Prebound
ISBN: 0-385-17639-2 Paperback
Text copyright © 1983 by Lee J. Ames and Murray D. Zak

Library of Congress Cataloging in Publication Data

Ames, Lee J.
 Draw 50 monsters, creeps, superheroes, demons, dragons, nerds, dirts, ghouls, giants,
vampires, zombies and other curiosa . . .

 Summary: Step-by-step instructions for drawing monsters and other assorted creatures.
Includes Darth Vader, Frankenstein, the Hunchback of Notre Dame, and Jaws.
 1. Monsters in art—Juvenile literature. 2. Animals, Mythical, in art—Juvenile literature.
3. Drawing—Technique—Juvenile literature. [1. Monsters in art. 2. Drawing — Technique]
I. Title. II. Title: Draw fifty monsters, creeps, superheroes, demons, dragons, nerds, dirts,
ghouls, giants, vampires, zombies and other curiosa . . .
 NC825.M6A47 1983 741.2′4 80-3006

30 29

To the jokesters down at Whaler's
and to Walter, loved so well...

Thanks, Holly!
Thanks, Tamara!
Thanks to Doug Bergstreser for the idea.

To the Reader

A wild and wacky collection of monsters and other fantastic creatures awaits you in this book, and by following simple, step-by-step instructions, you can draw each and every one of them, from the Bride of Frankenstein to Sasquatch.

Start by gathering your equipment. You will need paper, medium and soft pencils, and a kneaded eraser (available at art supply stores). You may also wish to have on hand India ink, a fine brush or pen, and a compass.

Next, pick the creature of your choice — you need not start with the first illustration. As you begin, keep in mind that the first few steps — the foundation of the drawing — are the most important. The whole picture will be spoiled if they are not right. So, follow these steps *very carefully,* keeping the lines as light as possible. So that they can be clearly seen, these lines are shown darker in this book than you should draw them. You can lighten your marks by gently pressing them with the kneaded eraser.

Make sure step one is accurate before you go on to step two. To check your own accuracy, hold the work up to a mirror after a few steps. By reversing the image, the mirror gives you a new view of the drawing. If you haven't done it quite right, you may notice that your drawing is out of proportion or off to one side.

You can reinforce the drawing by going over the completed final step with India ink and a fine brush or pen. When the ink has dried, gently remove the pencil lines with the kneaded eraser.

Don't get discouraged if, at first, you find it difficult to duplicate the shapes pictured. Just keep at it, and in no time you'll be able to make the pencil go just where you wish. Drawing, like any other skill, requires patience, practice, and perseverance.

Remember, this book presents only one method of drawing. In a most enjoyable way, it will help you develop a certain skill and control. But there are many other ways of drawing to which you can apply this skill, and the more of them you explore, the more interesting your drawings will be.

Lee J. Ames

To the Parent or Teacher

The ability to make a credible, amusing, or attractive drawing never fails to fill a child with pride and a sense of accomplishment. This in itself provides the motivation for a child to cultivate that ability further.

There are diverse approaches to developing the art of drawing. Some contemporary ways stress freedom of expression, experimentation, and self-evaluation of competence and growth. More traditional is the "follow me, step-by-step" method which teaches through mimicry. Each approach has its own value, and one need not exclude the other.

This book teaches a way of drawing based on the traditional method. It will give young people the opportunity to produce skillful, funny drawings of monsters and other creatures by following simple instructions. After completing a number of such drawings, the child will almost surely have picked up some of the fundamentals of handling and controlling the materials and of creating believable forms, and a sense of the discipline needed to master the art of drawing. From here, the child can continue with other books in the DRAW 50 series — and at the same time, explore other methods of drawing which he or she will now be better equipped to deal with.

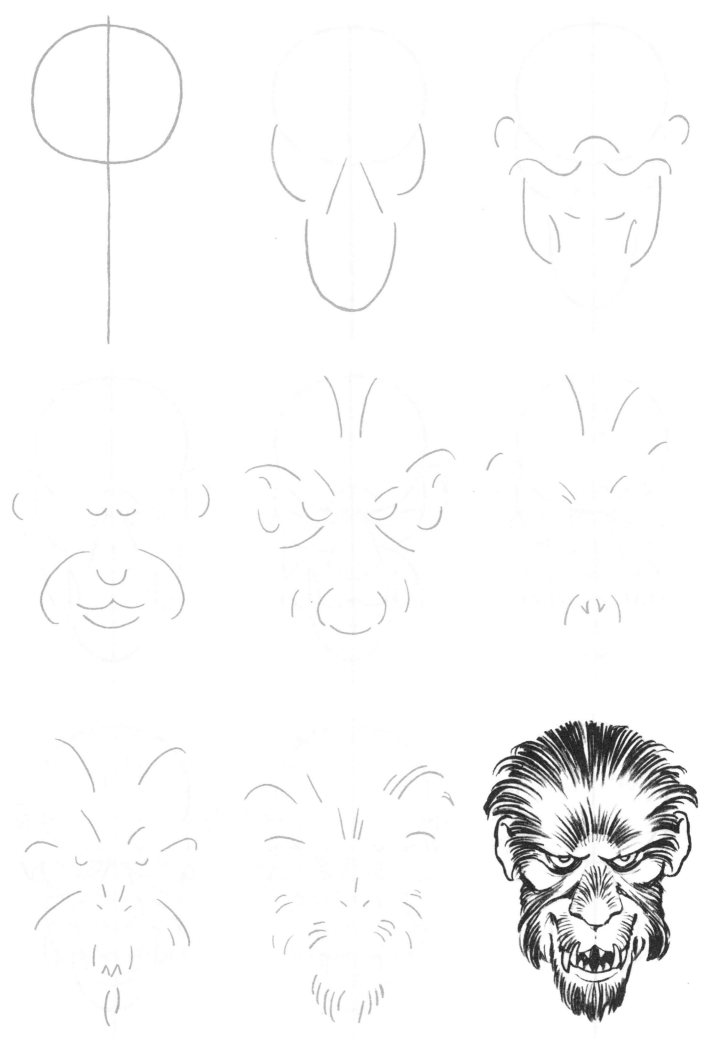

Werner Werewolf

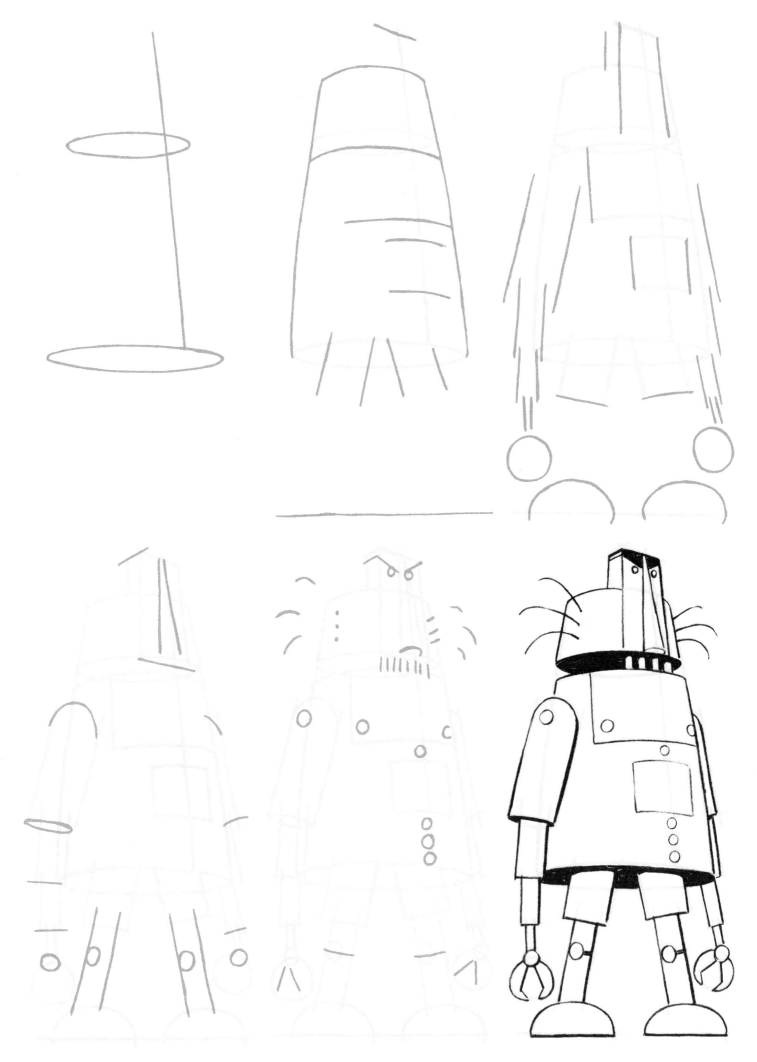

UR2EZ

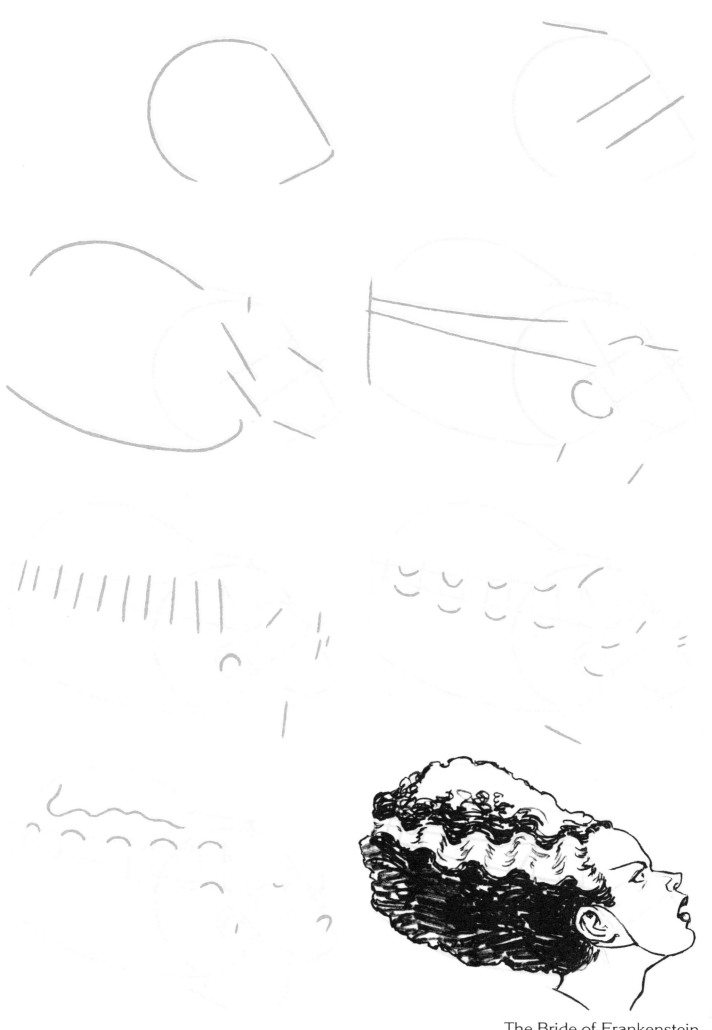

The Bride of Frankenstein

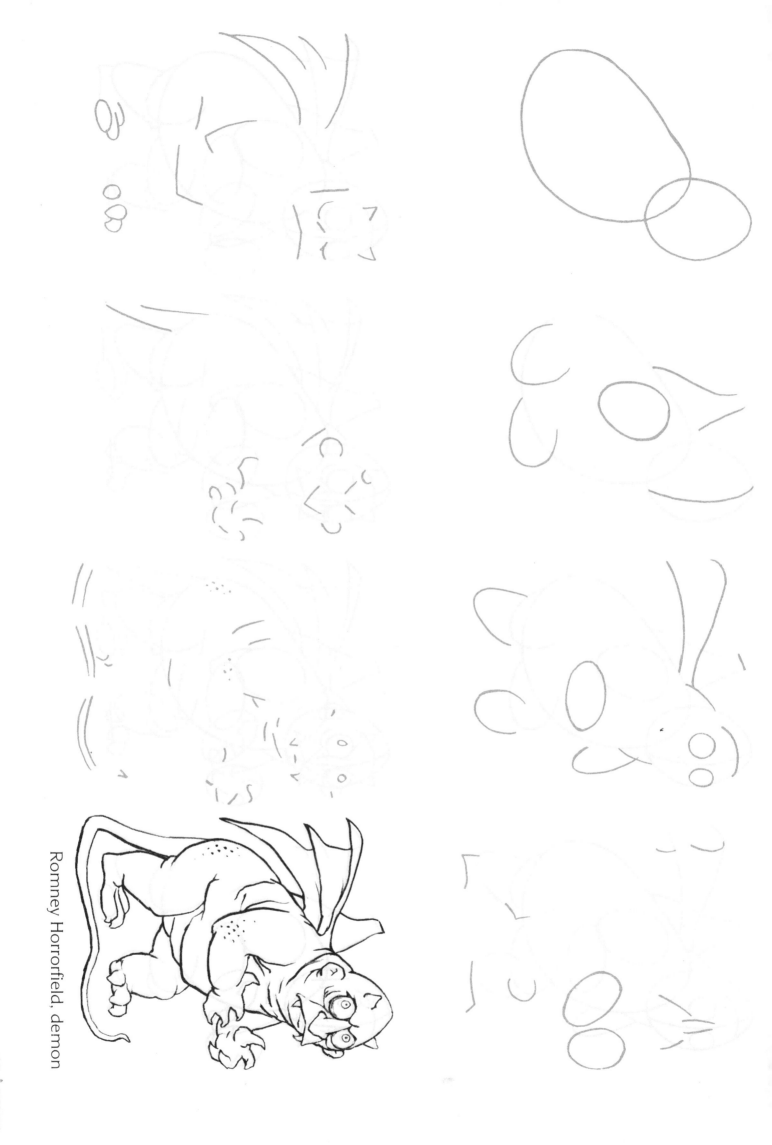

Romney Horrorfield, demon

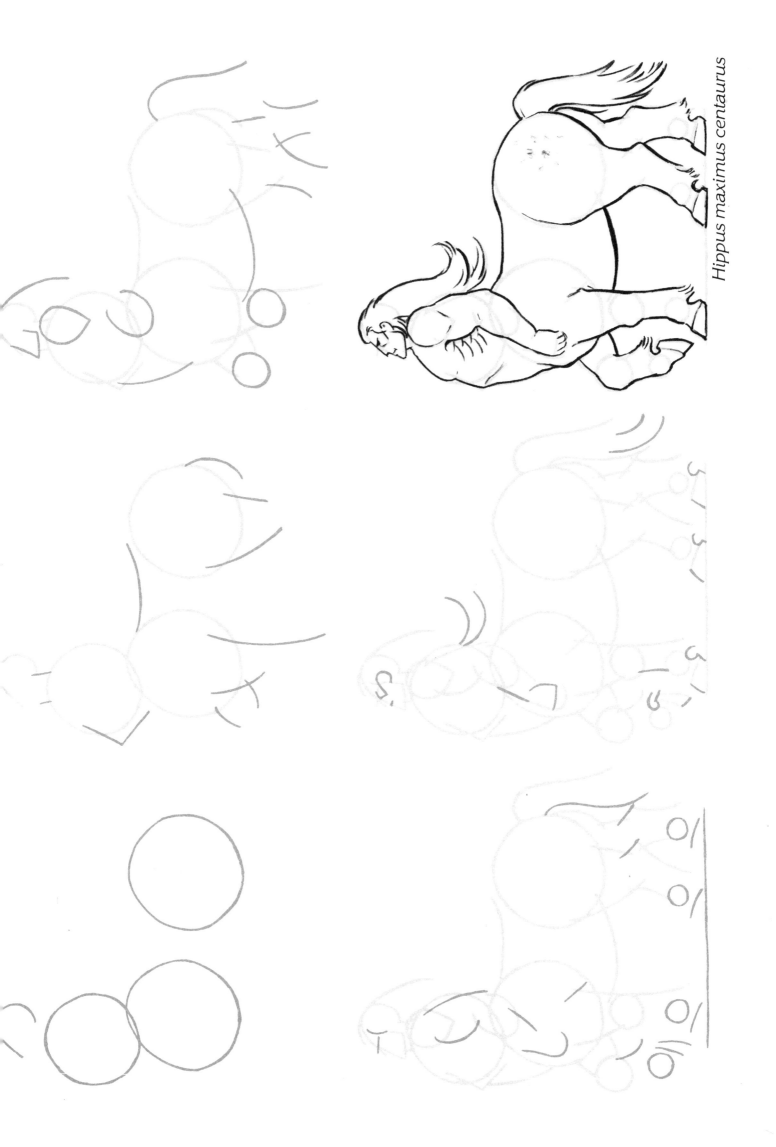

Hippus maximus centaurus

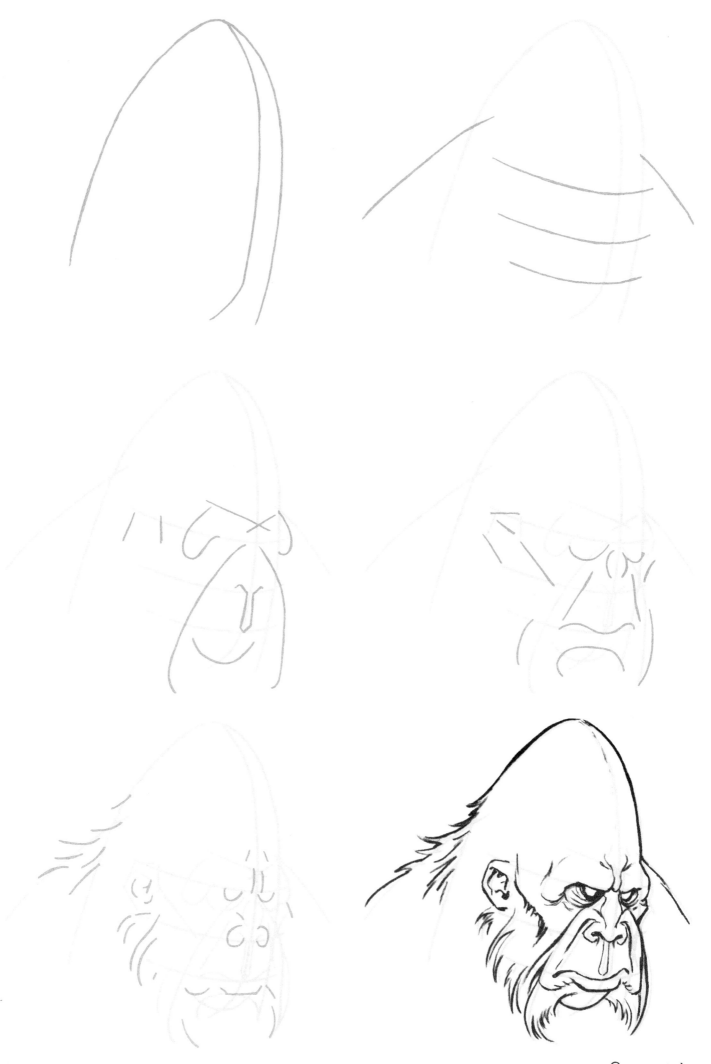

Sasquatch

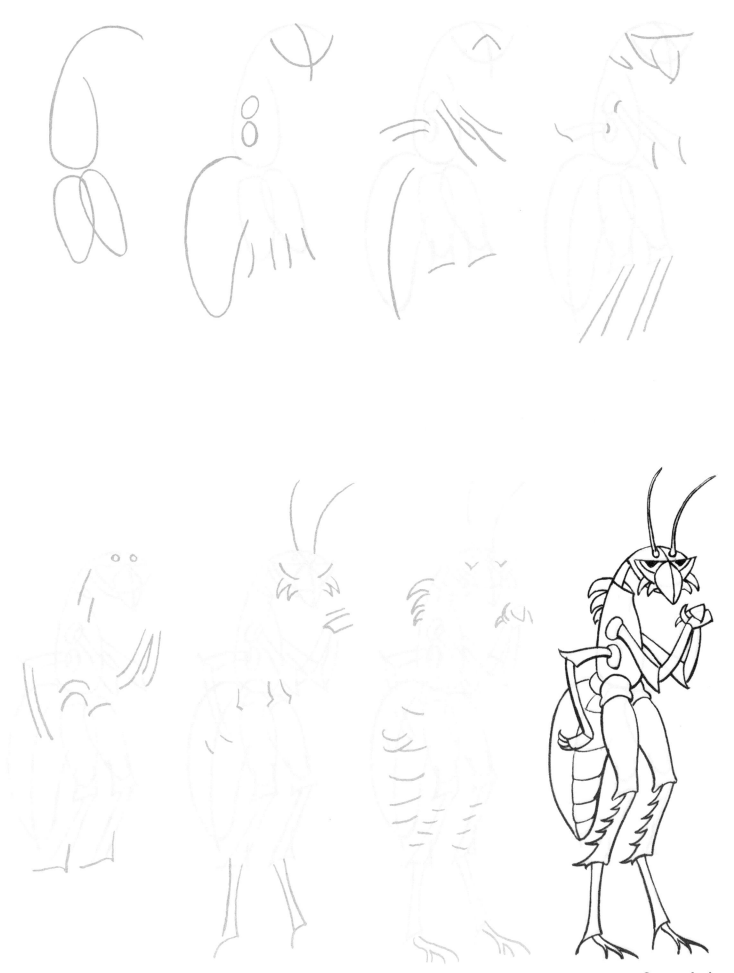

Super Itch

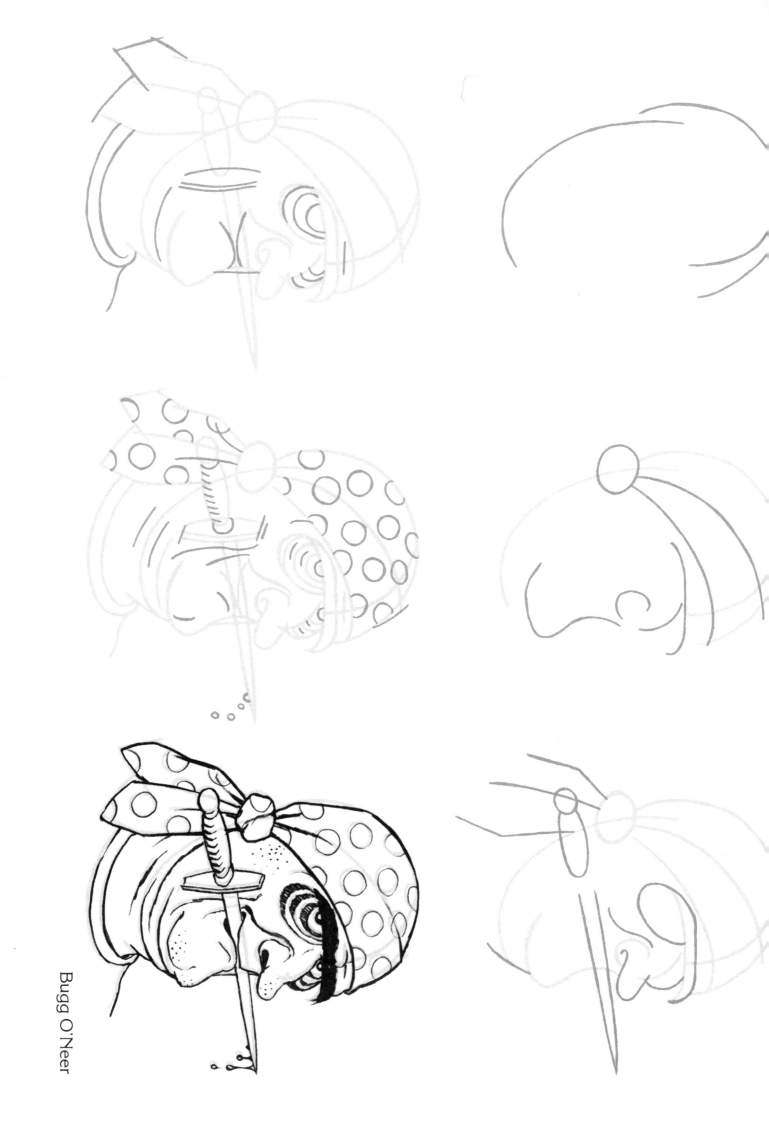

Bugg O'Neer

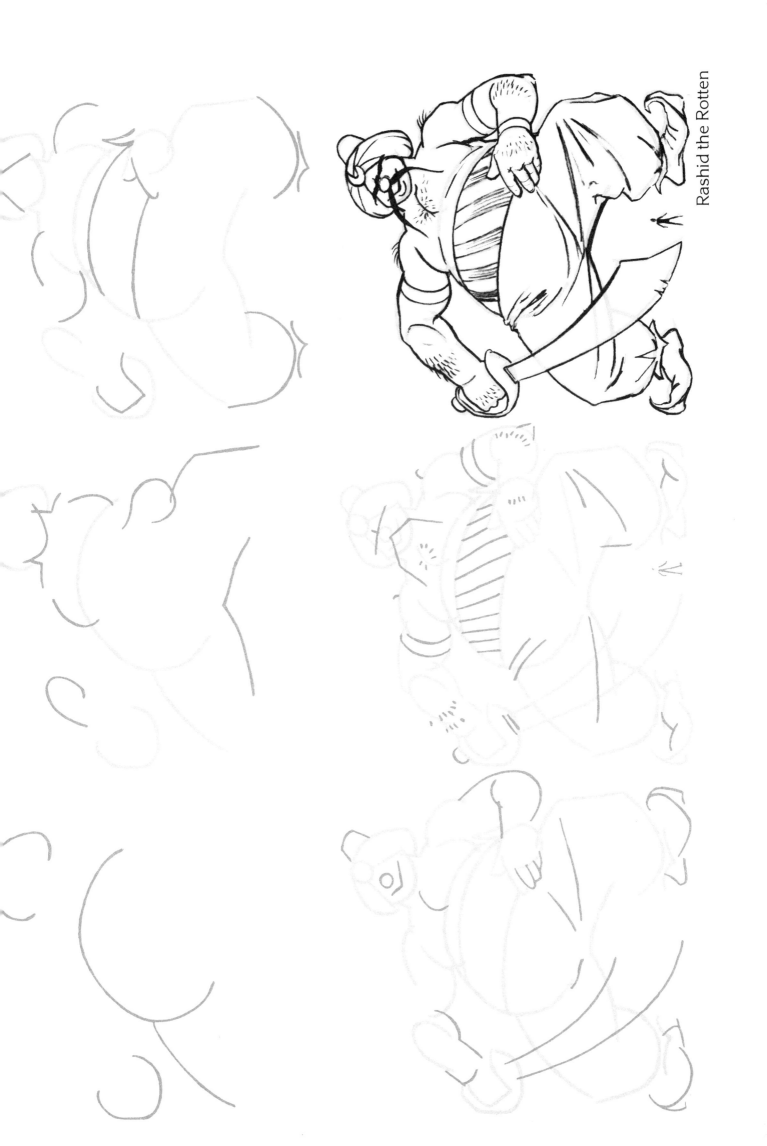

Rashid the Rotten

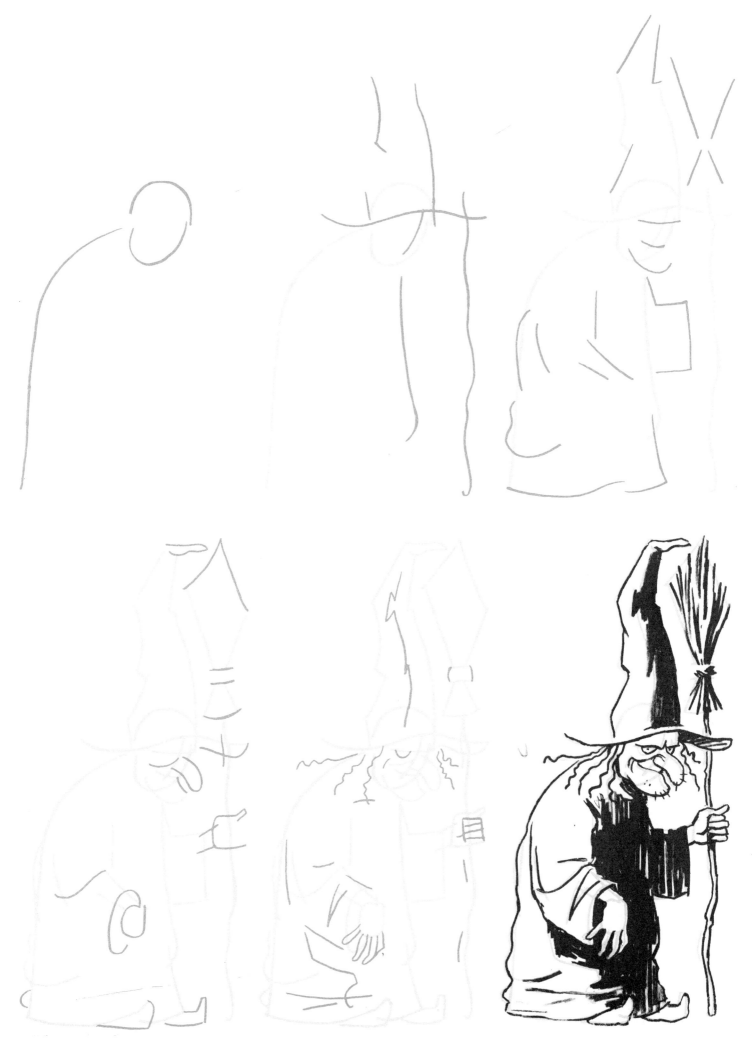

Wynsomme Warthead, witch

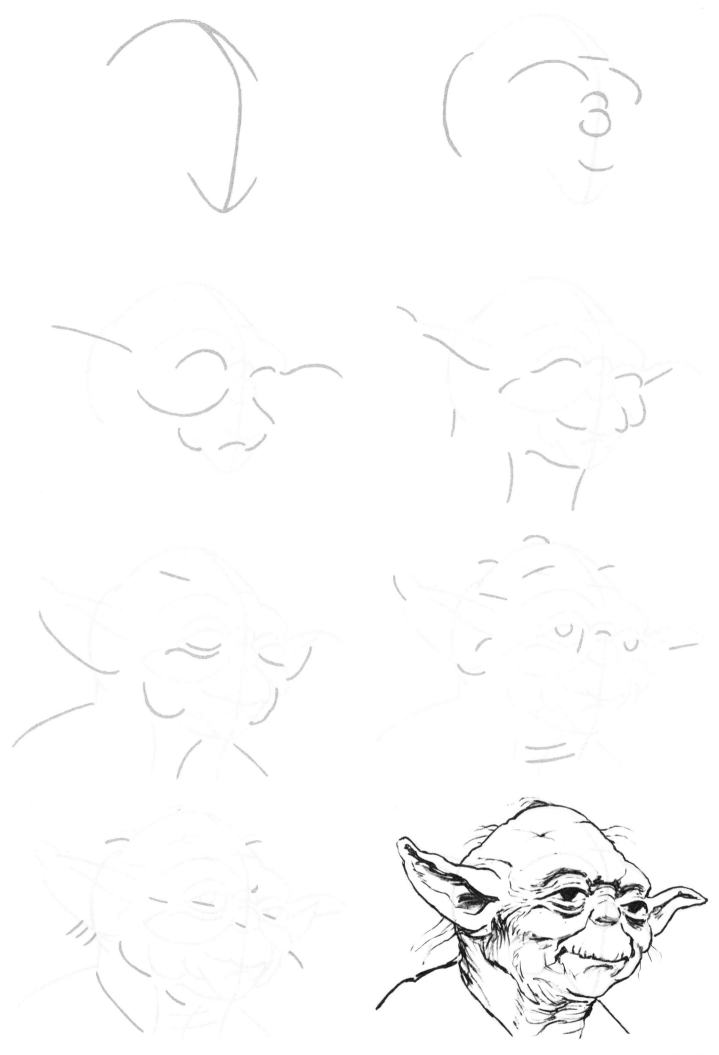

Yoda

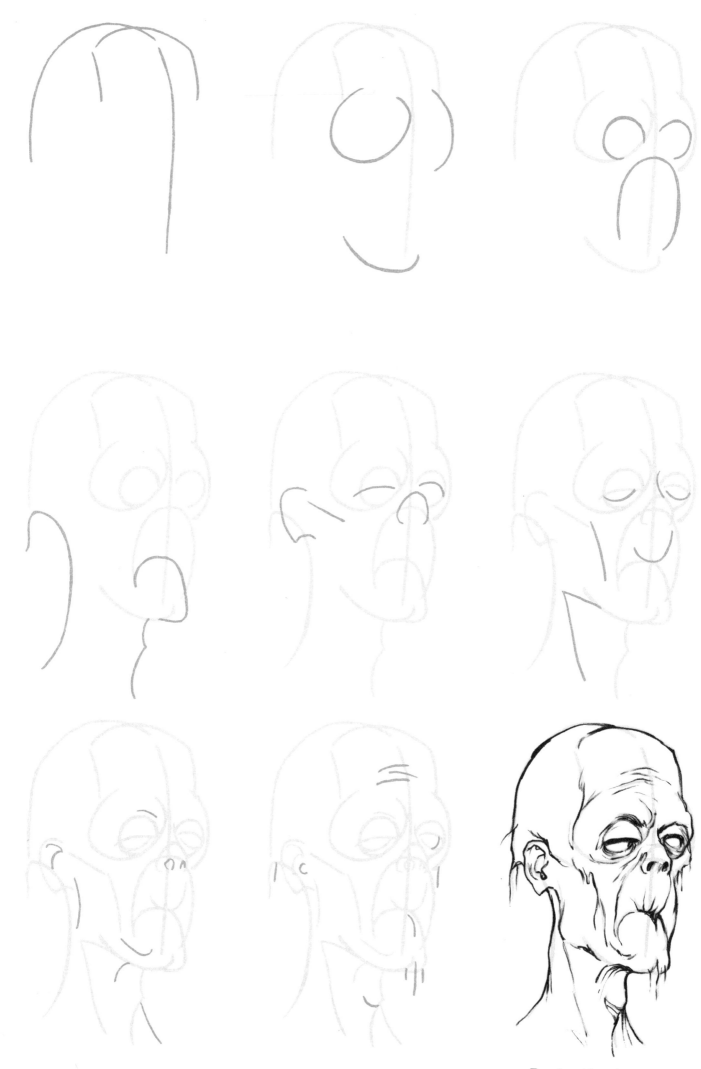

Reeko Mortis, zombie

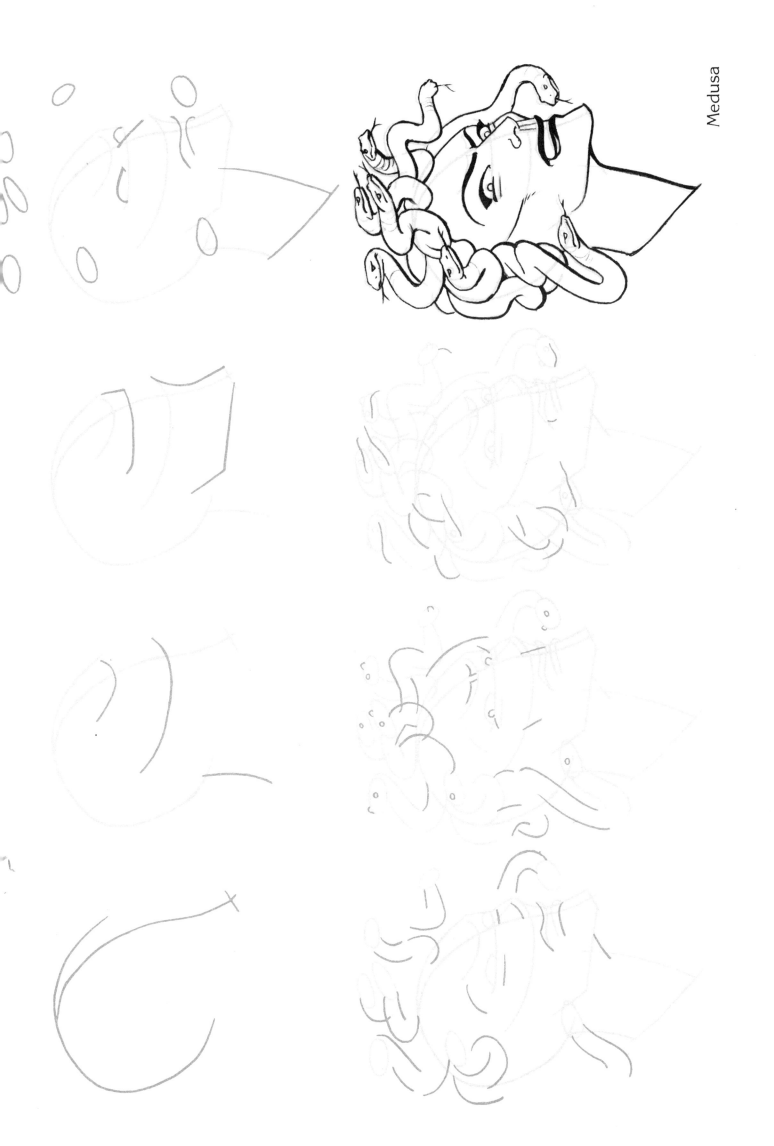

Medusa

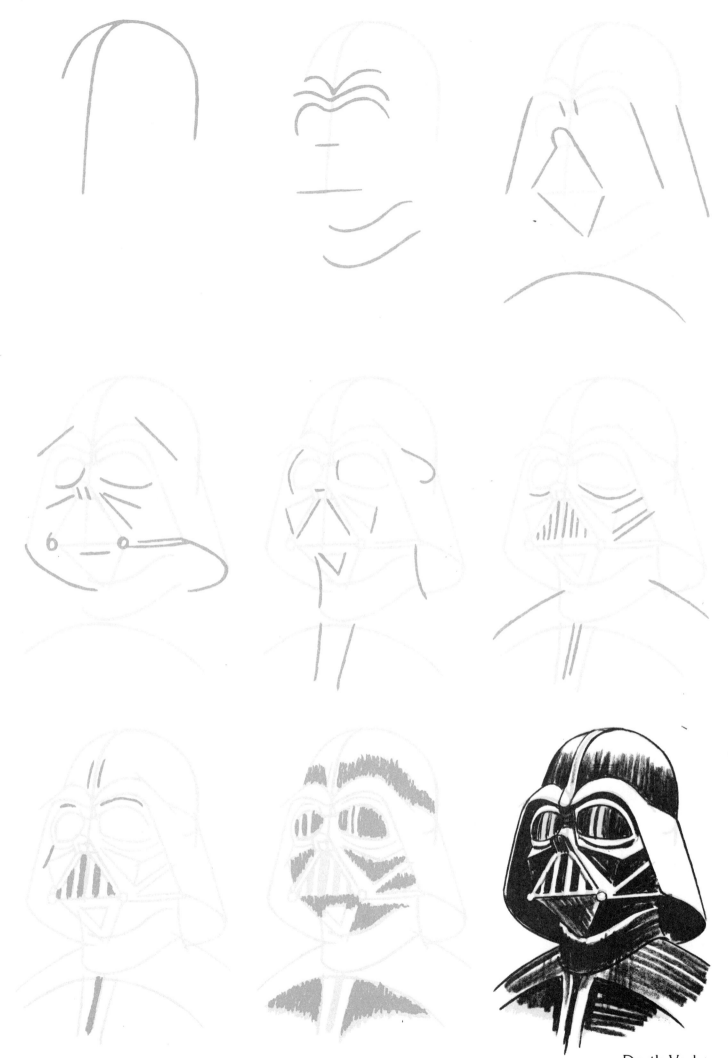

Darth Vader

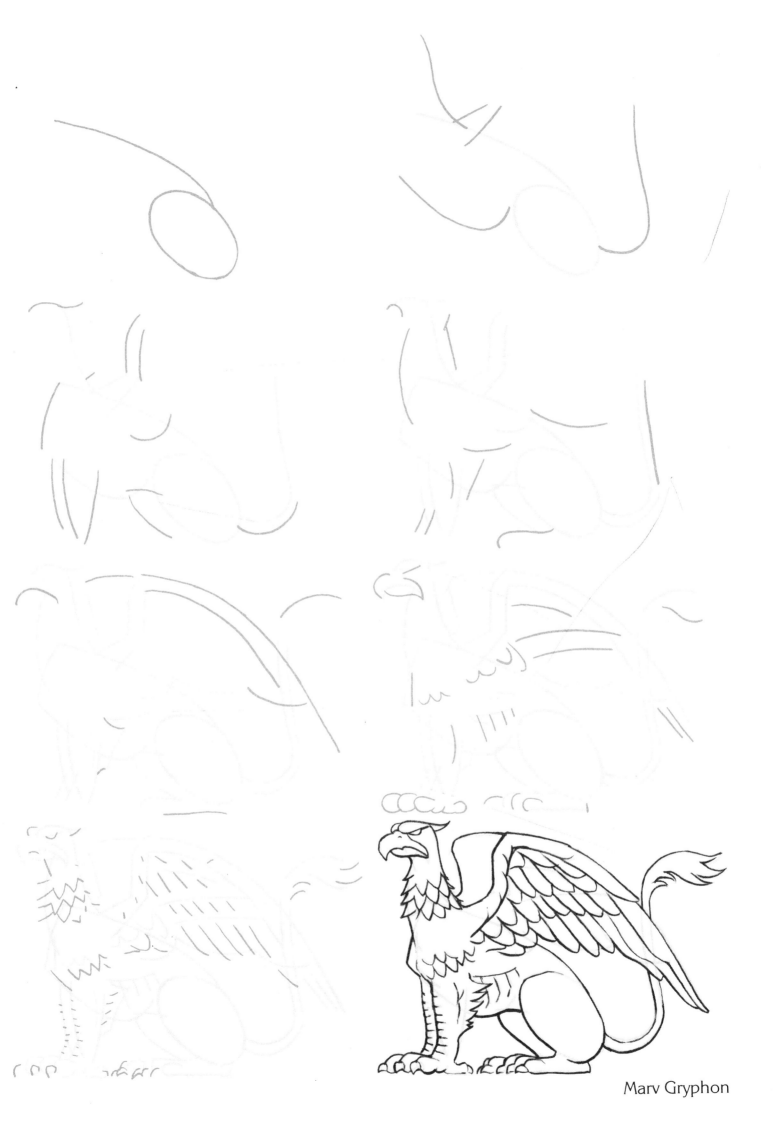

Marv Gryphon

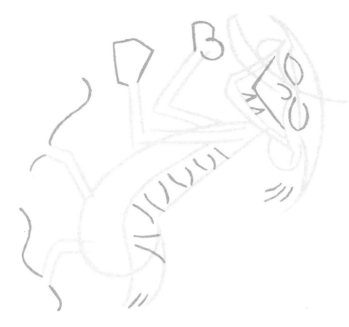

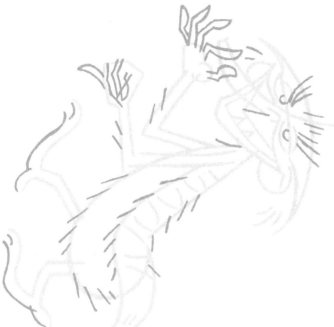

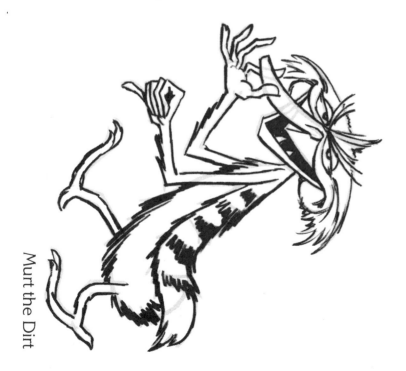

Murt the Dirt

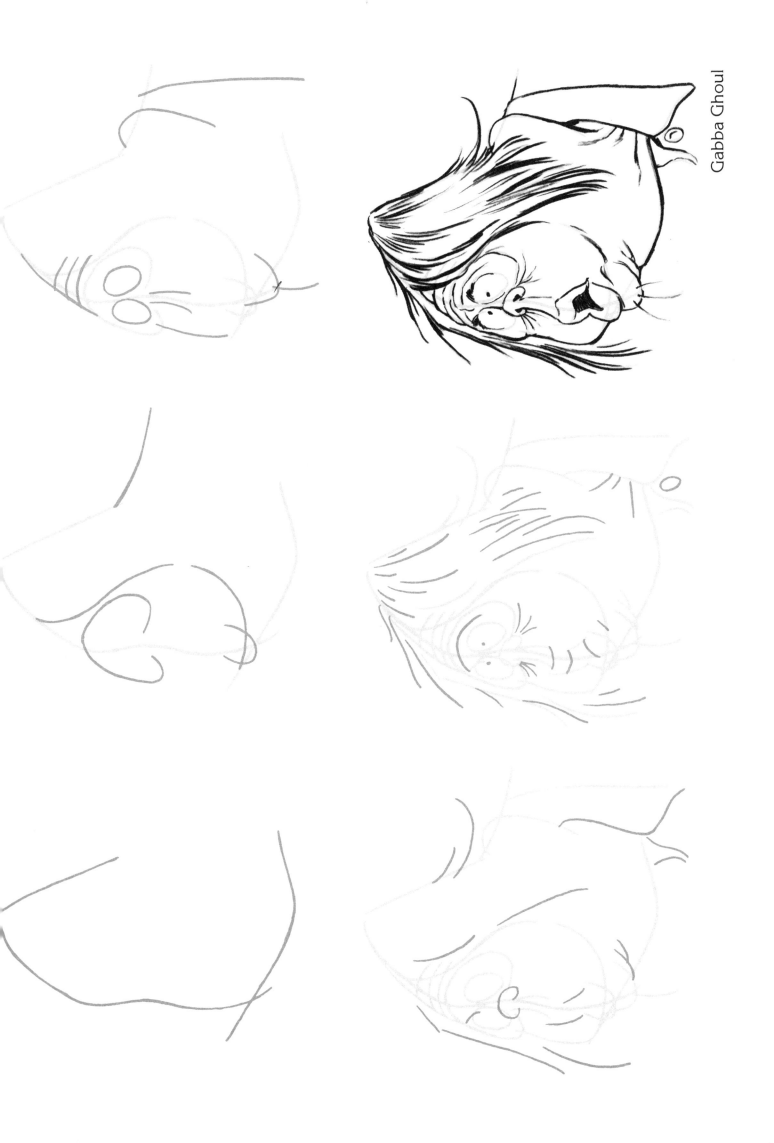

Gabba Ghoul

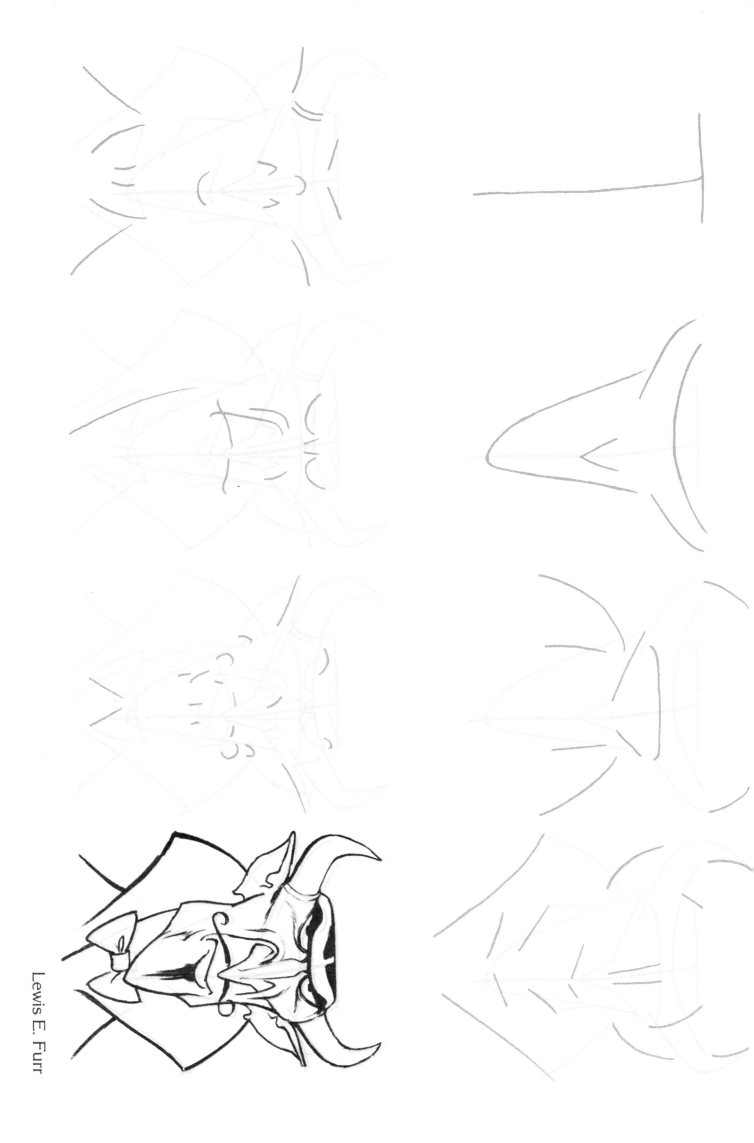

Lewis E. Furr

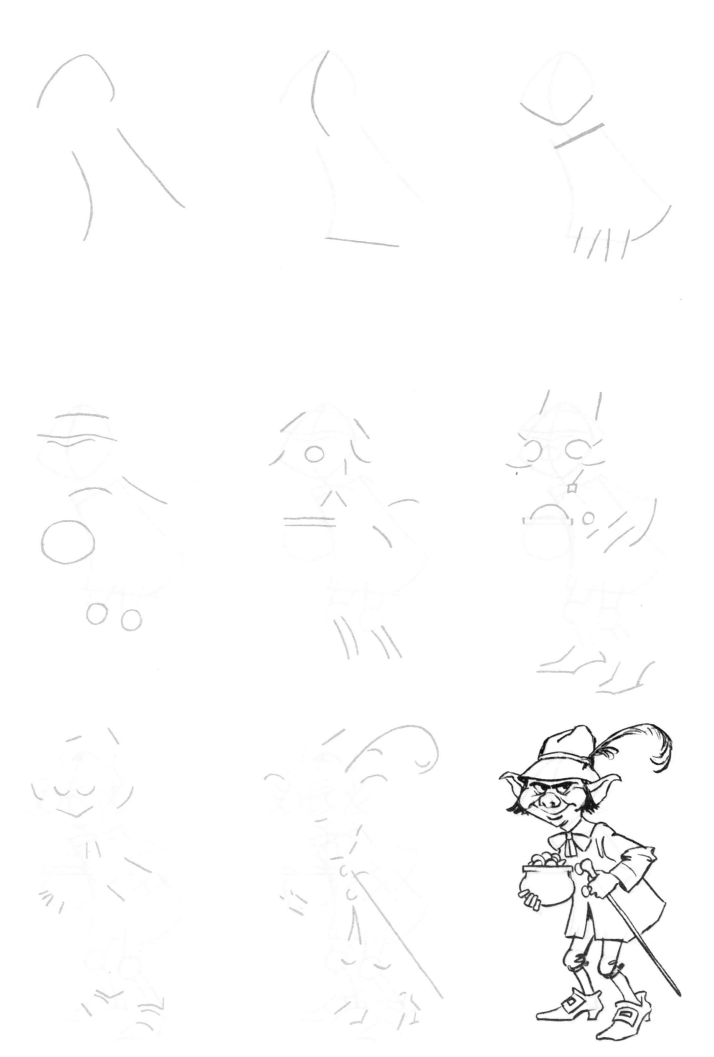

Wee Seamus Kildare, leprechaun

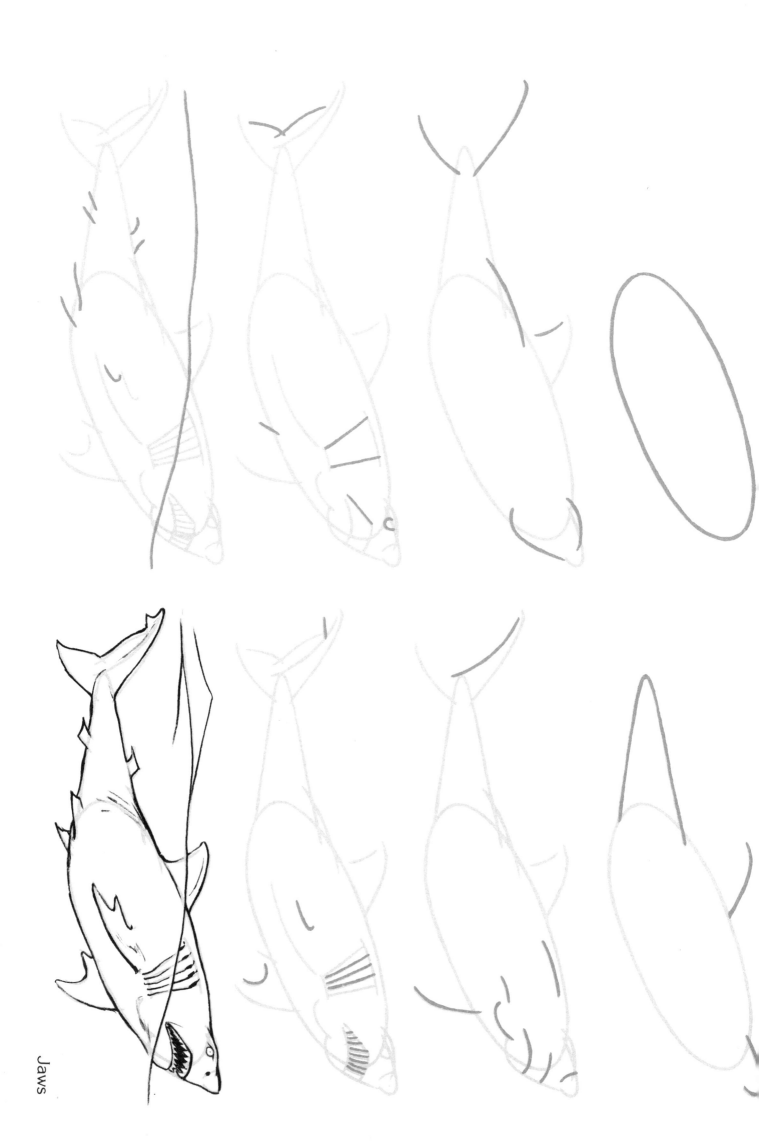

Jaws

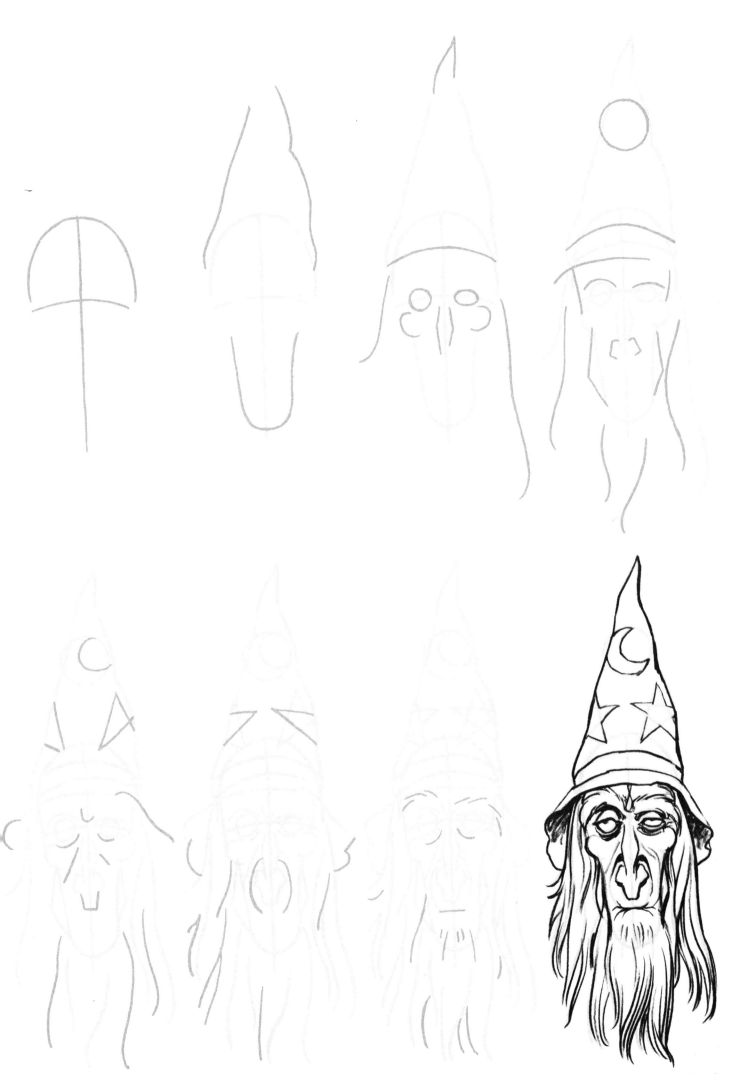

Egeni Chillingstone, warlock

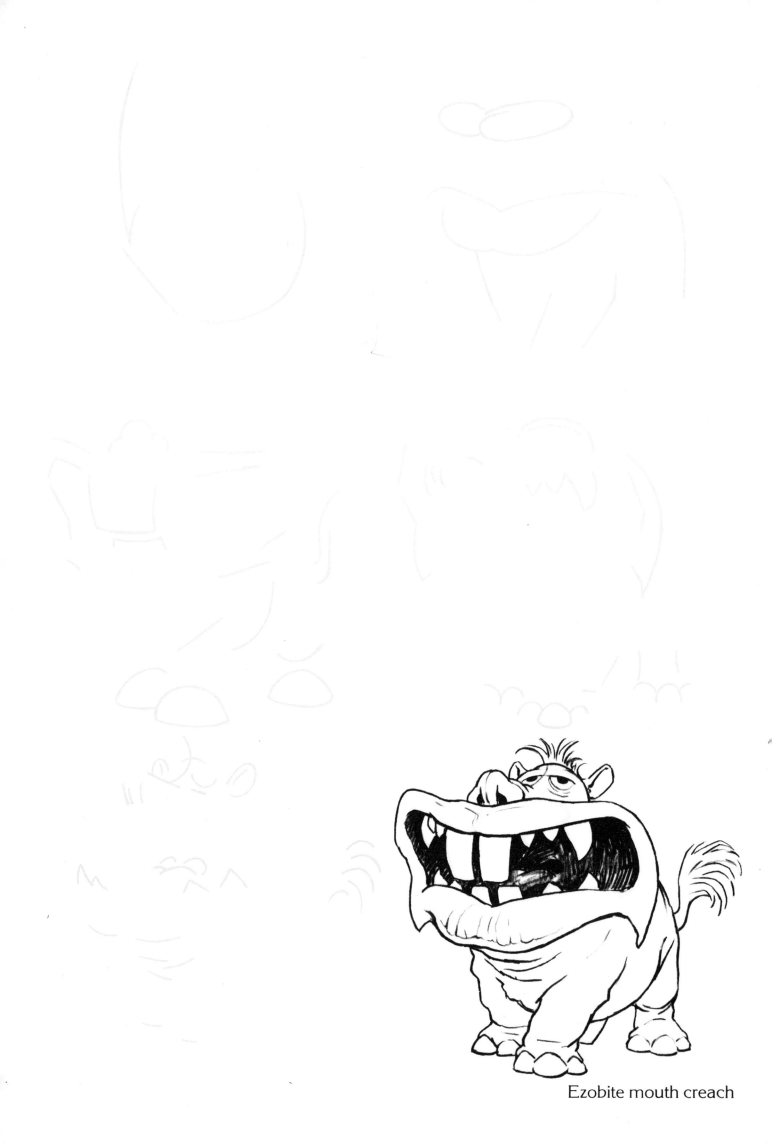

Ezobite mouth creach

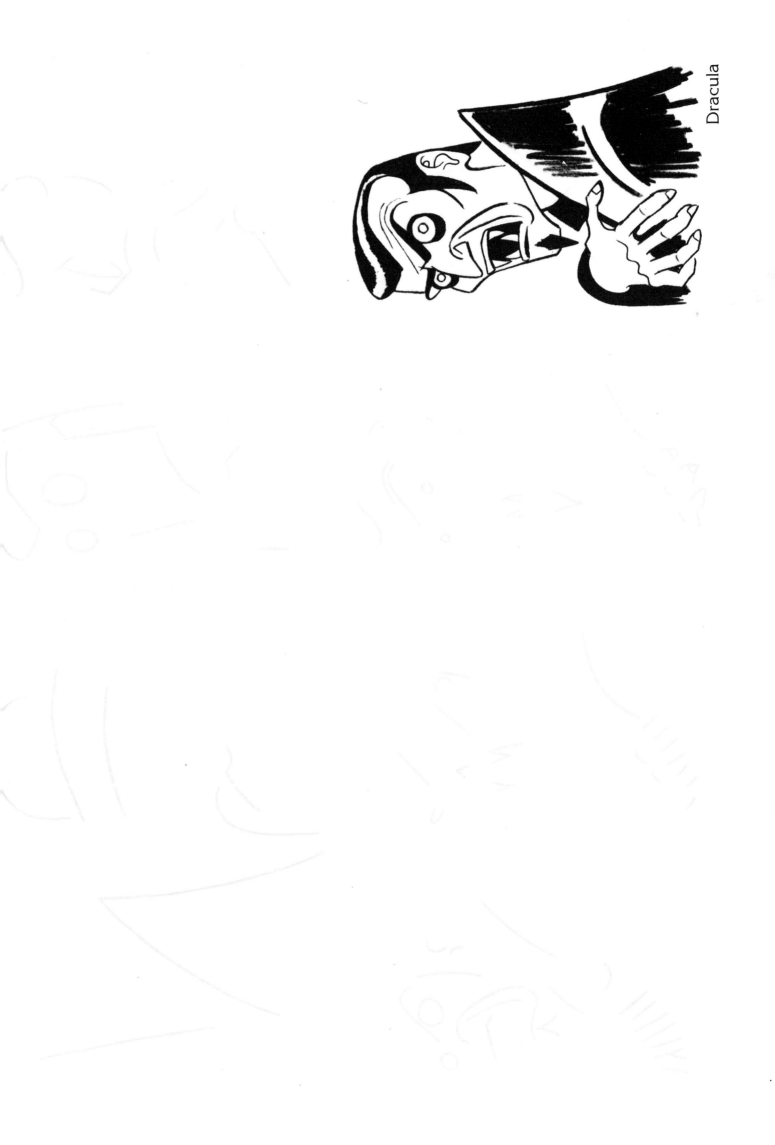

Dracula

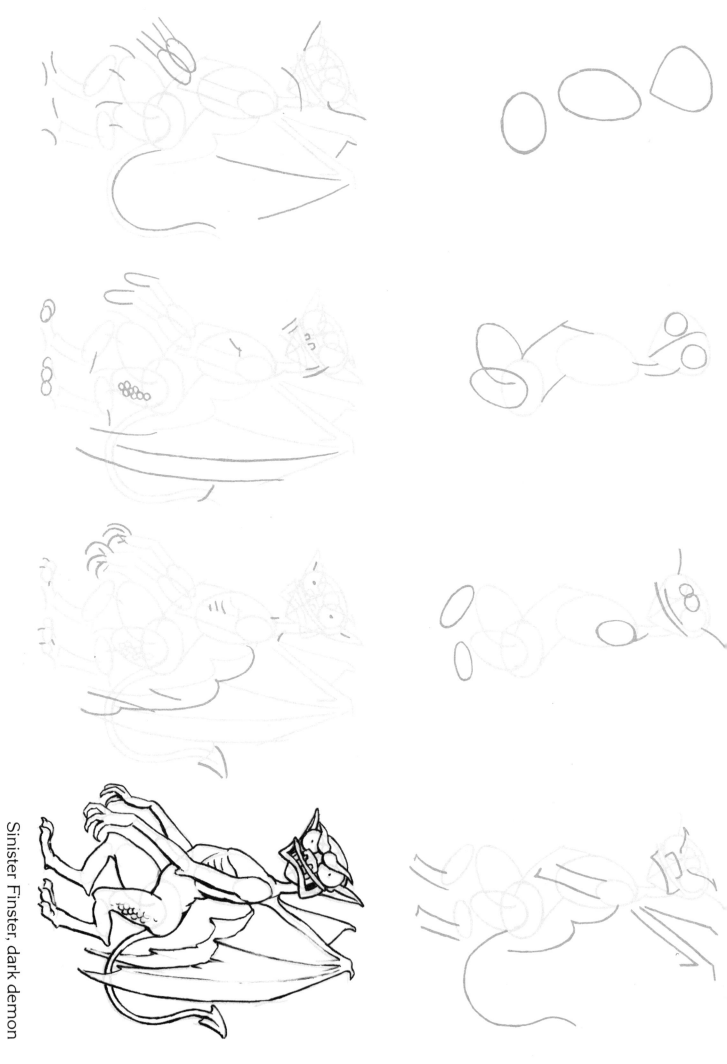

Sinister Finster, dark demon

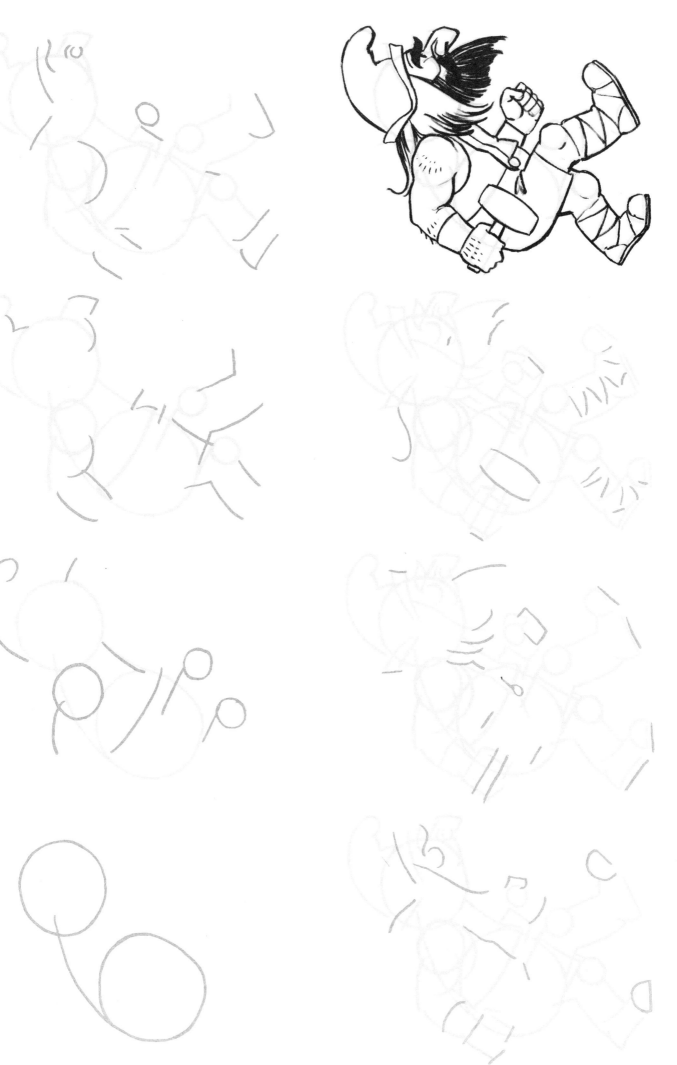

Feodor the Dwarf

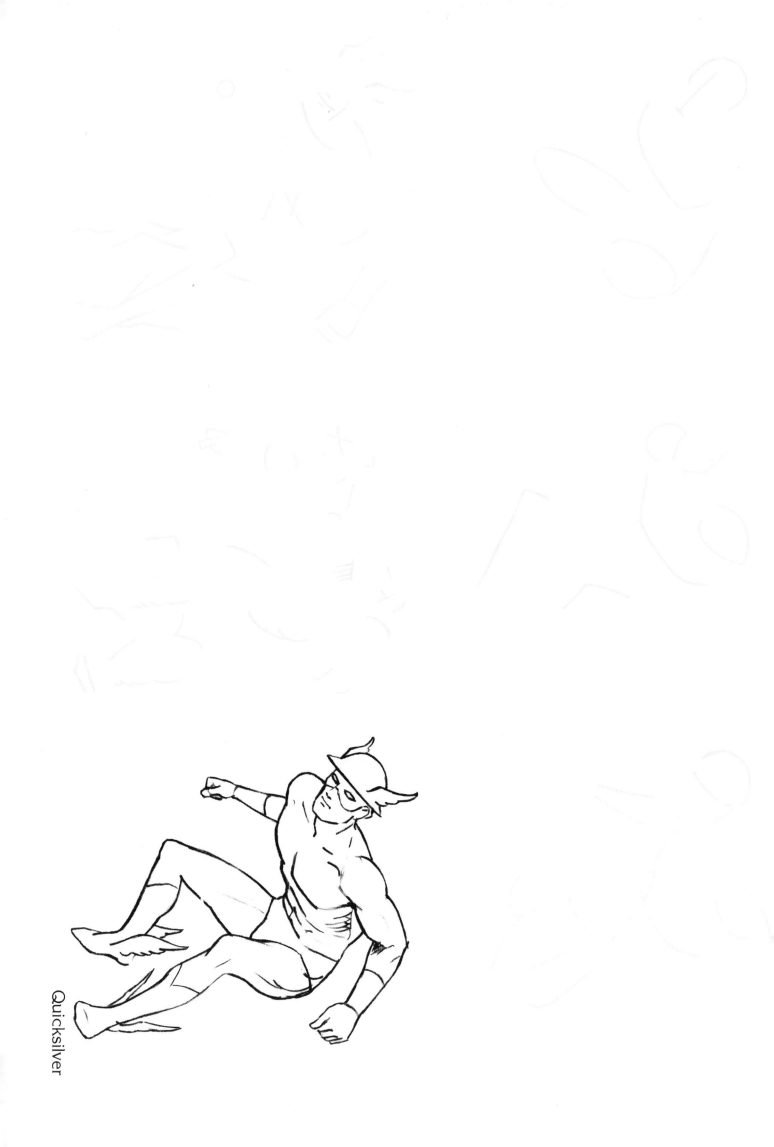

Quicksilver

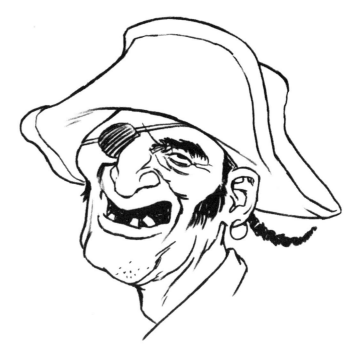

Clipper Gyp

Demon from the Second Planet Circling Sirius

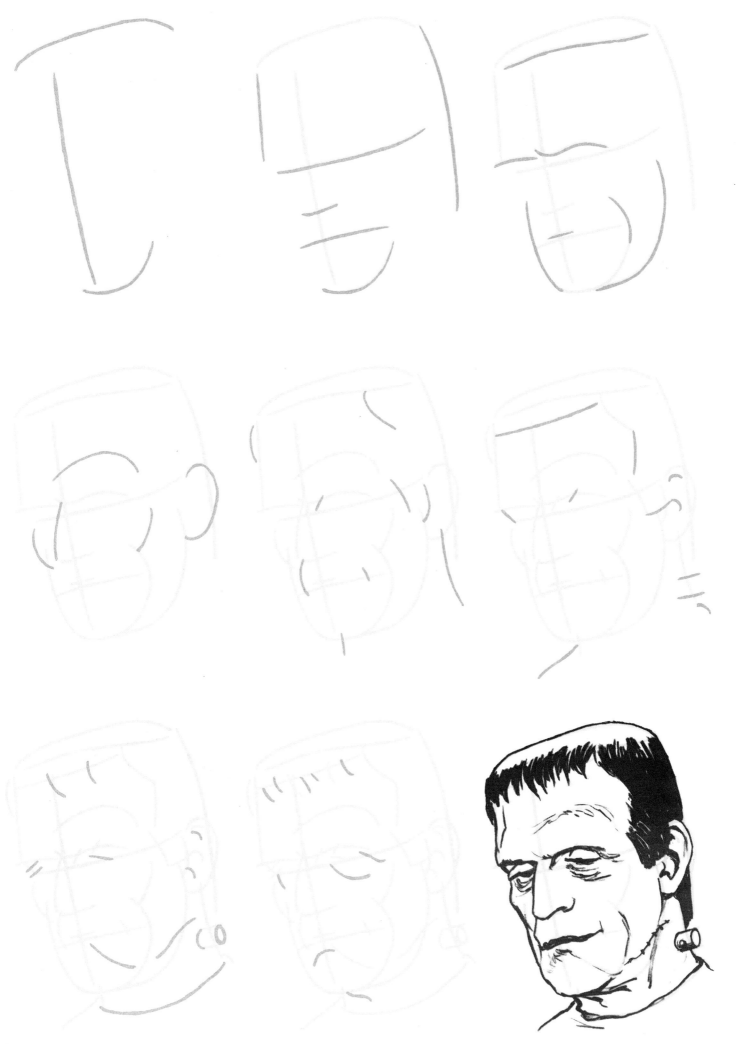

Frankenstein's Monster

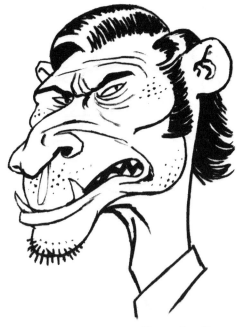

Rory LaGoon

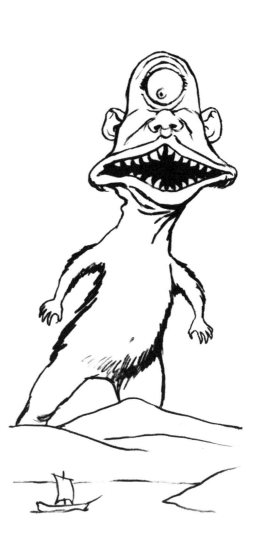

Cyclops

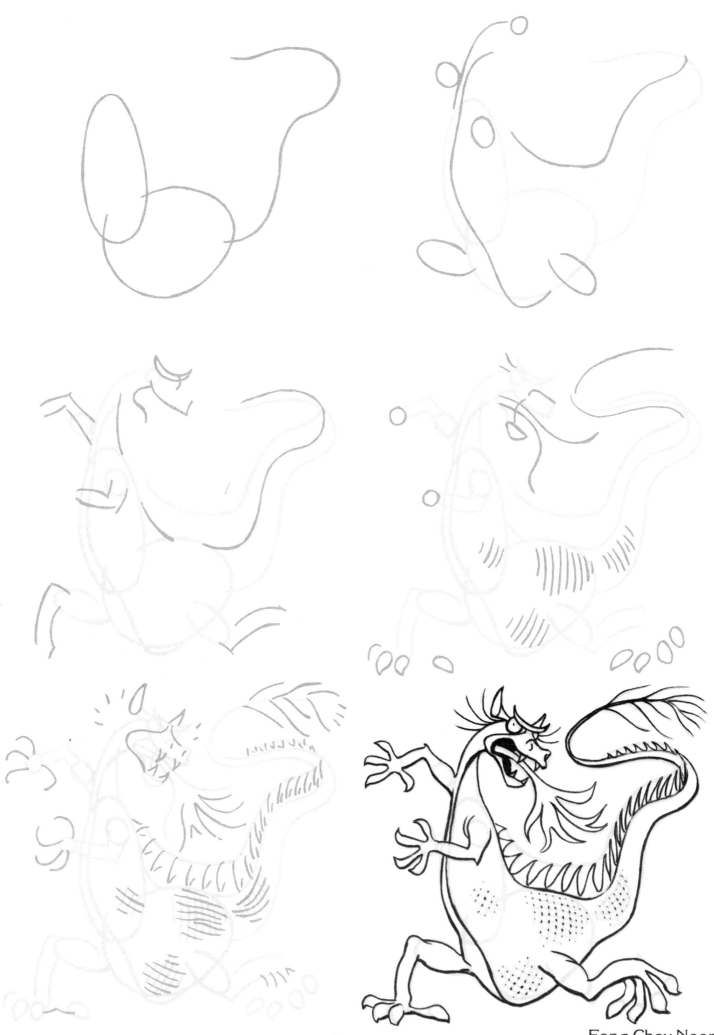

Fong Choy Noon

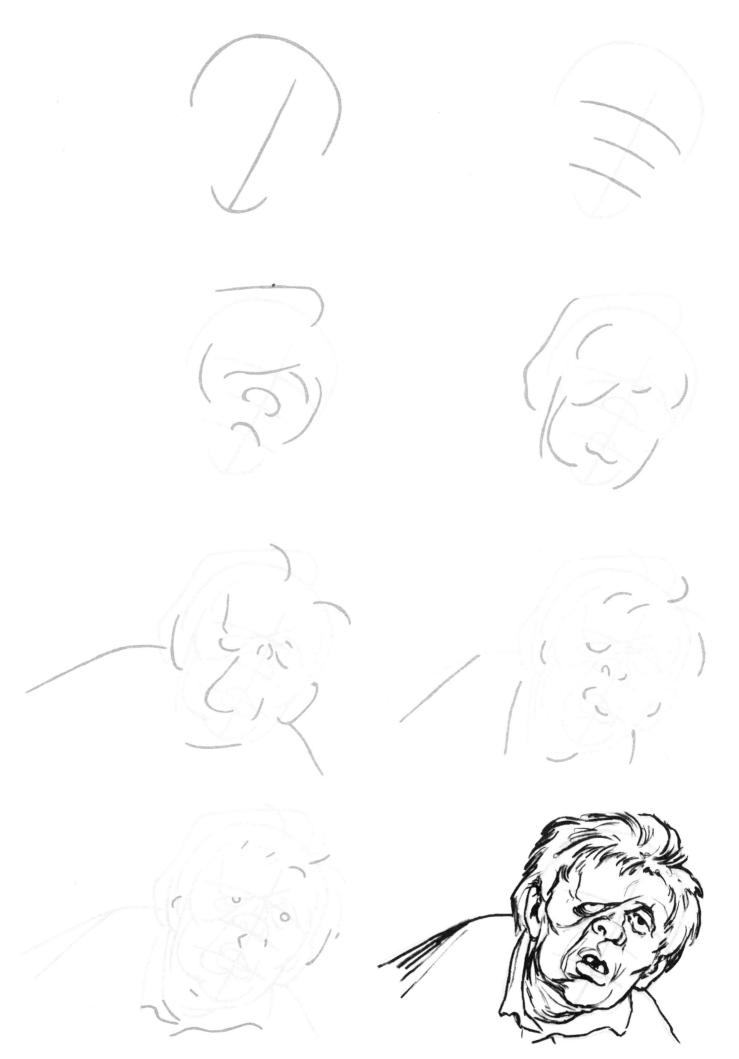

The Hunchback of Notre Dame

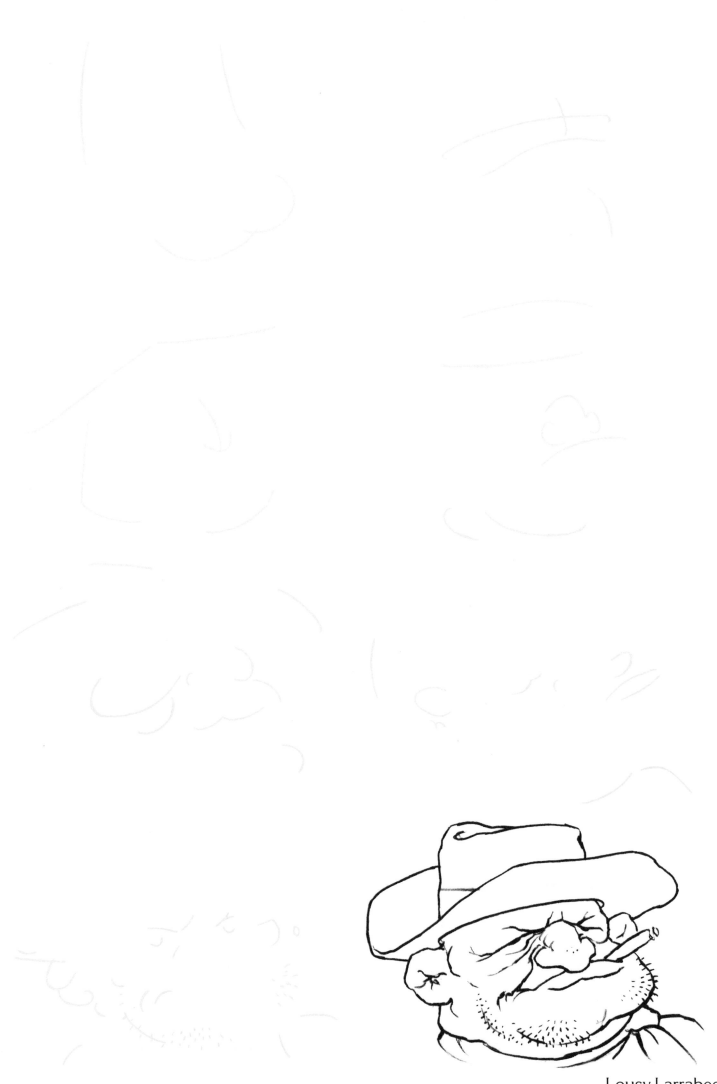

Lousy Larrabee

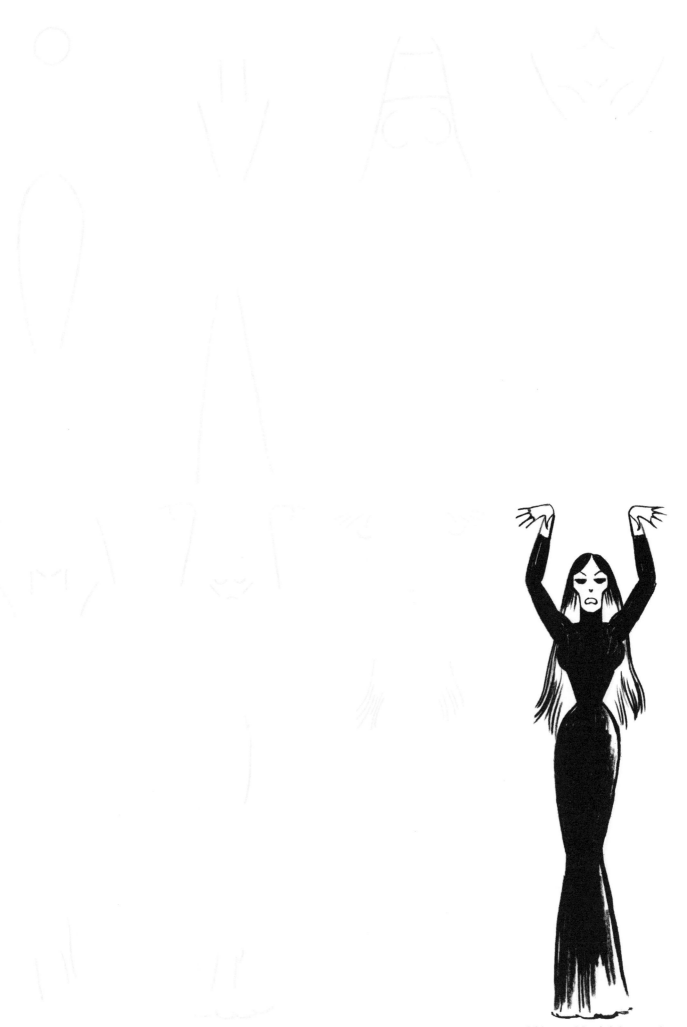

Vilma Knibblenecker

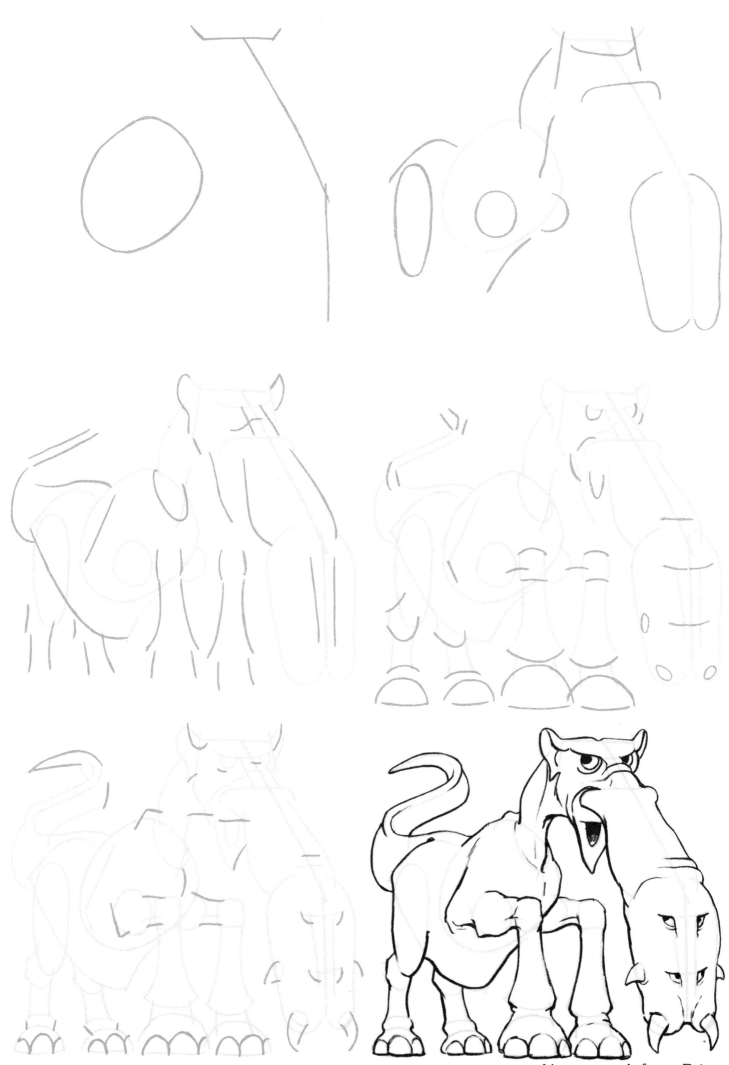

Nose creach from Brinza

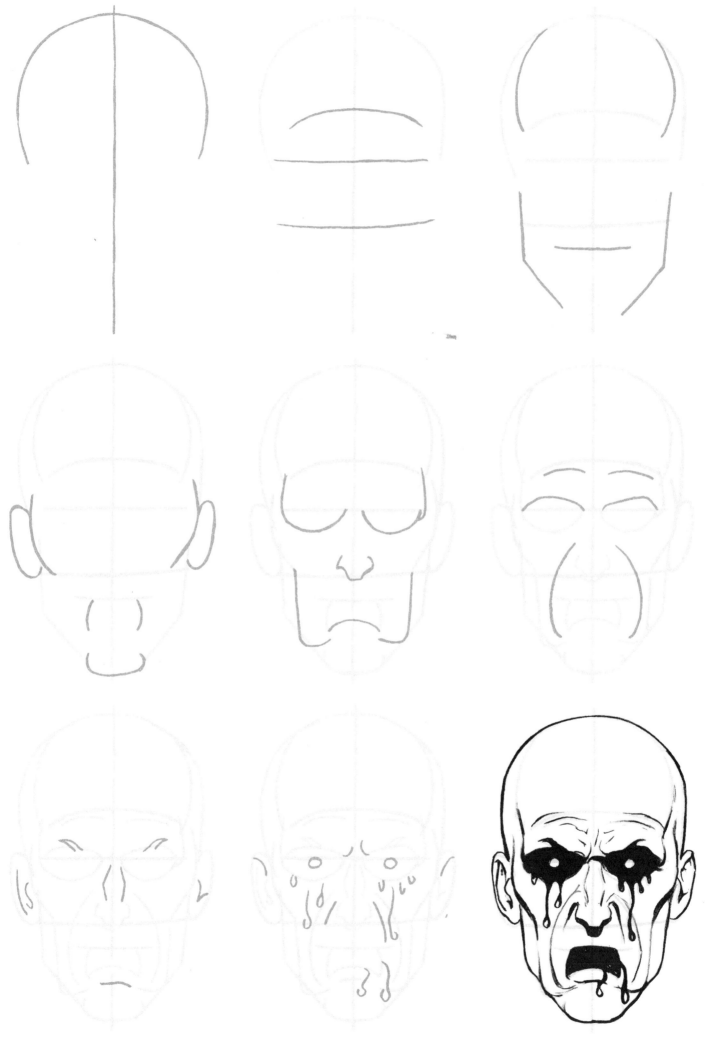

Bluddin Gaur, zombie

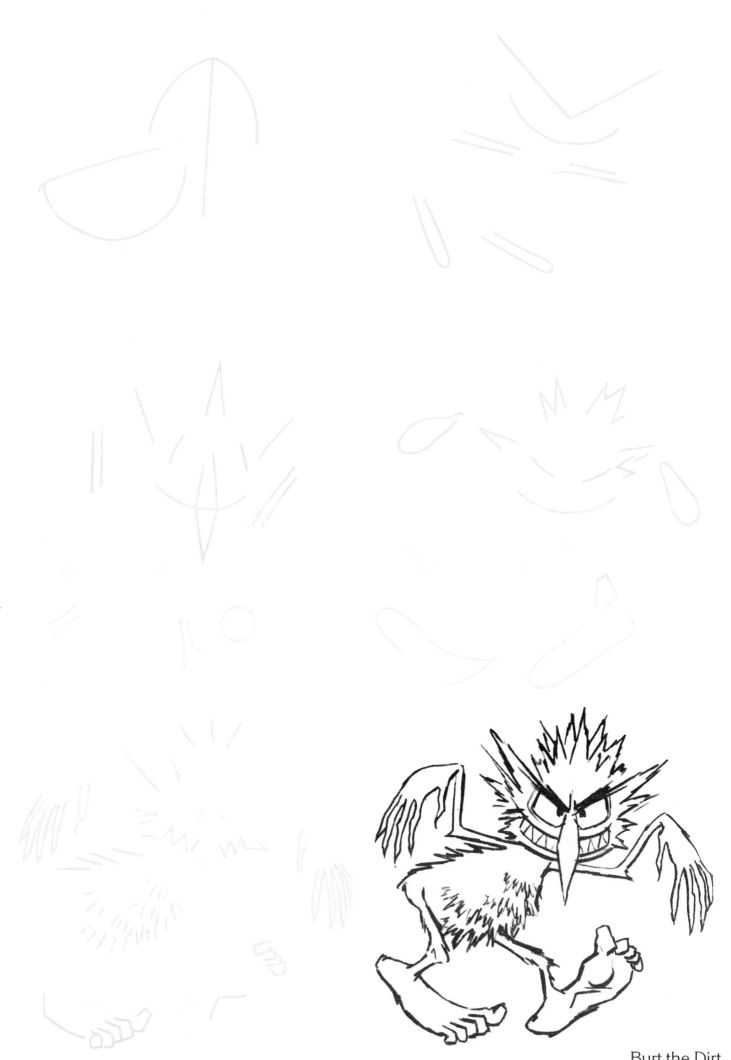

Burt the Dirt

Hercules

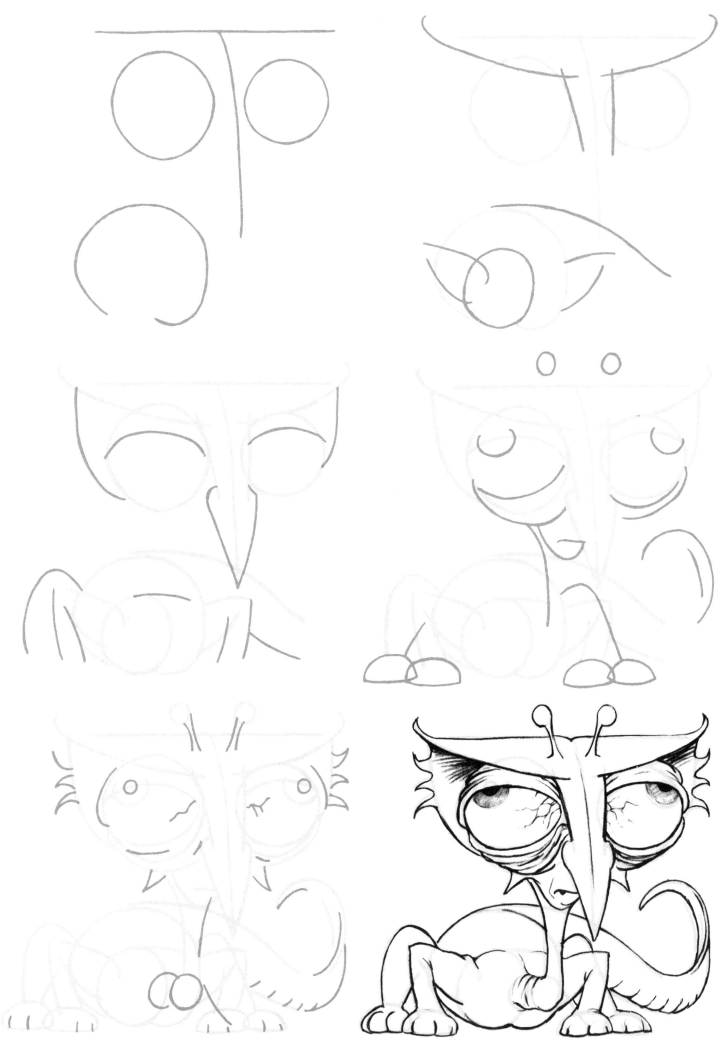

Ezobite eye creach

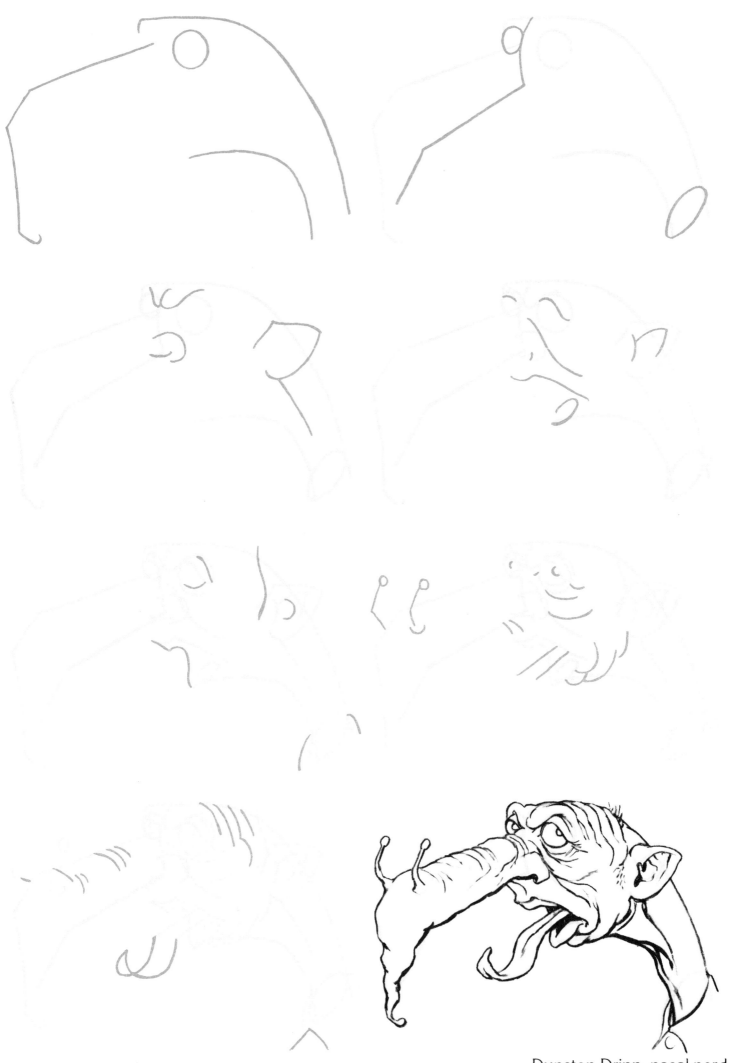

Dunston Dripp, nasal nerd

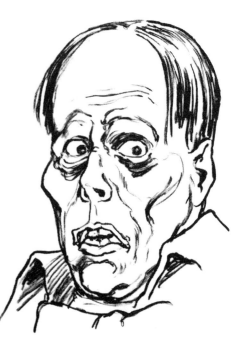

The Phantom of the Opera

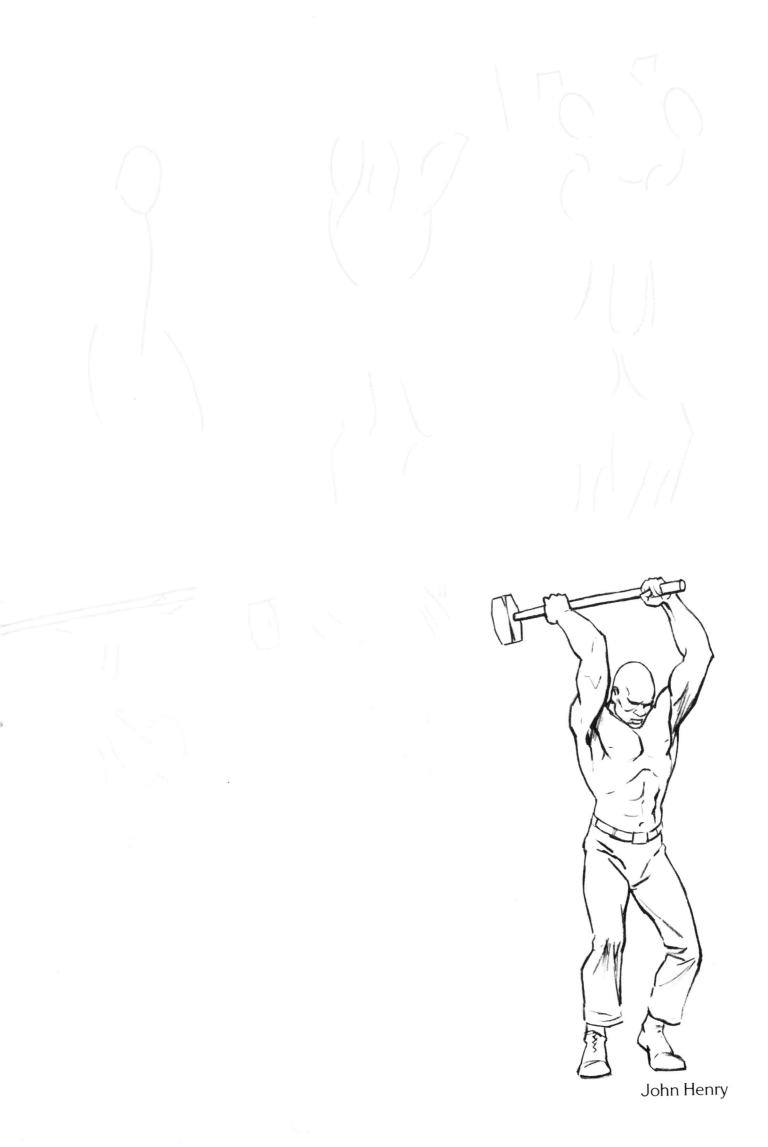

John Henry

Bad Bjorn, giant troll

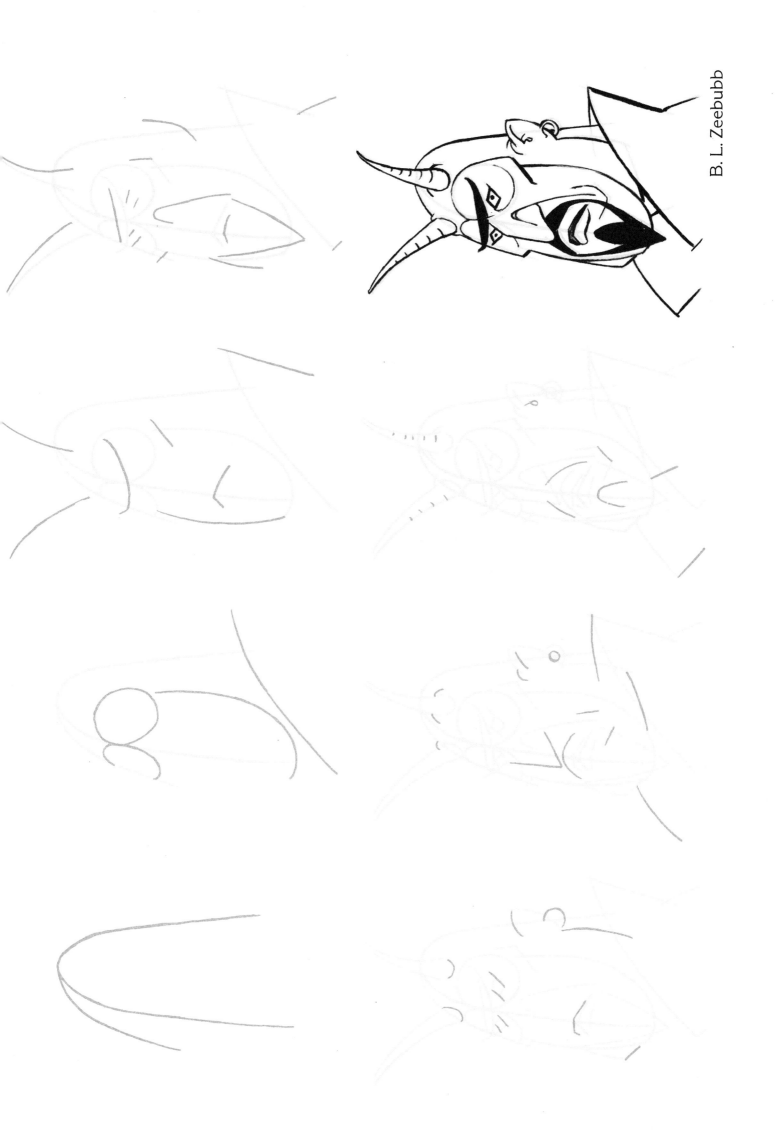

B. L. Zeebubb

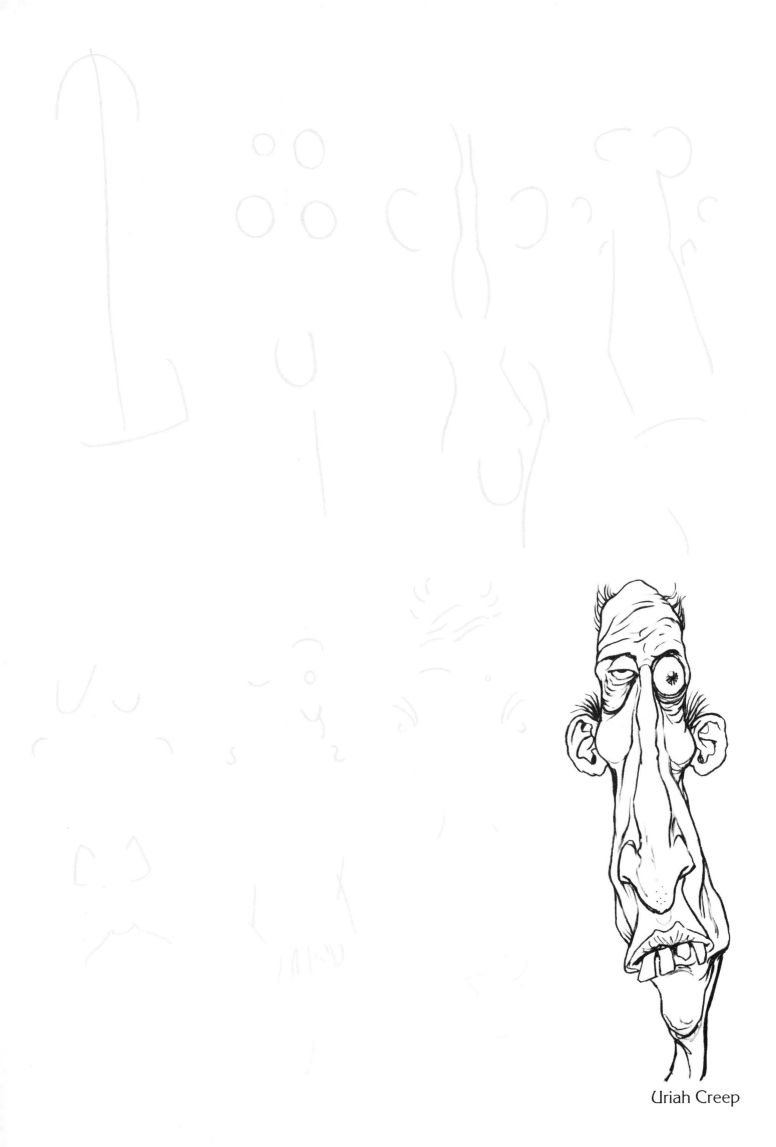

Uriah Creep

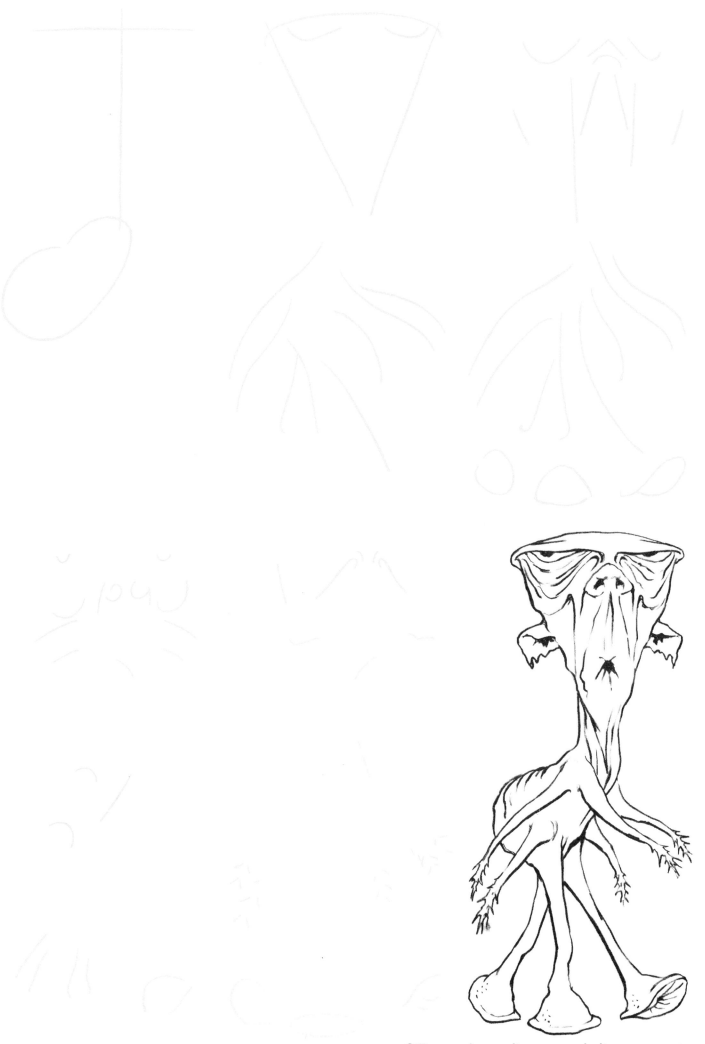

Sillawarsh, undiscovered slime monster

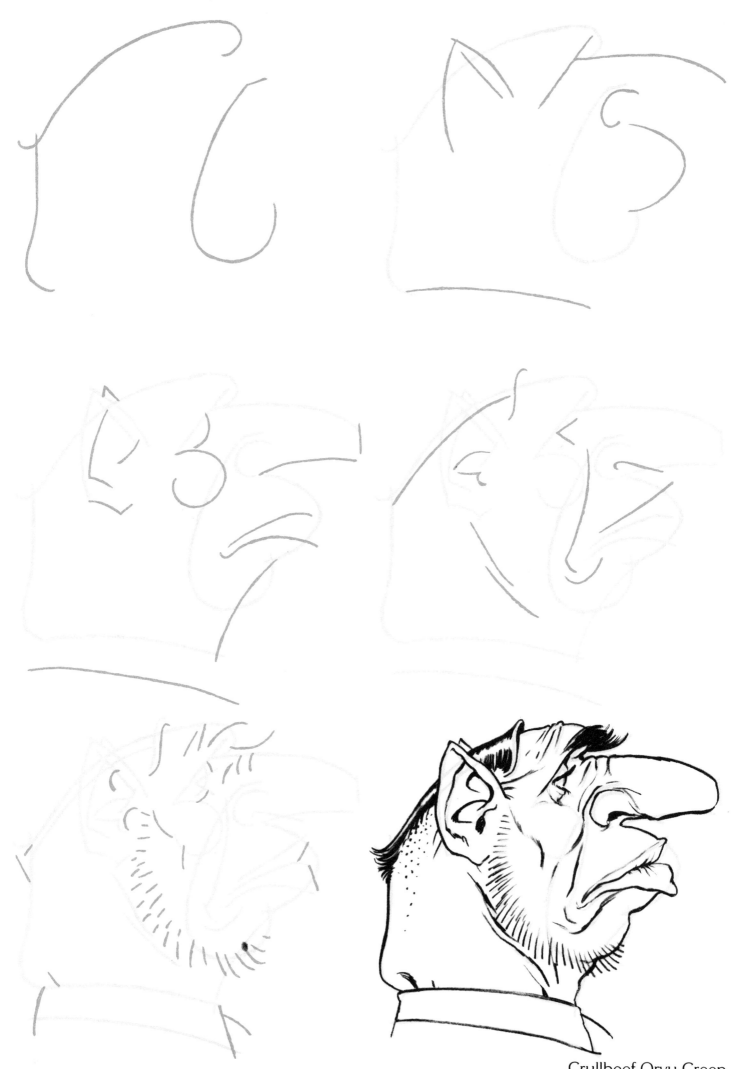

Crullbeef Oryu Creep

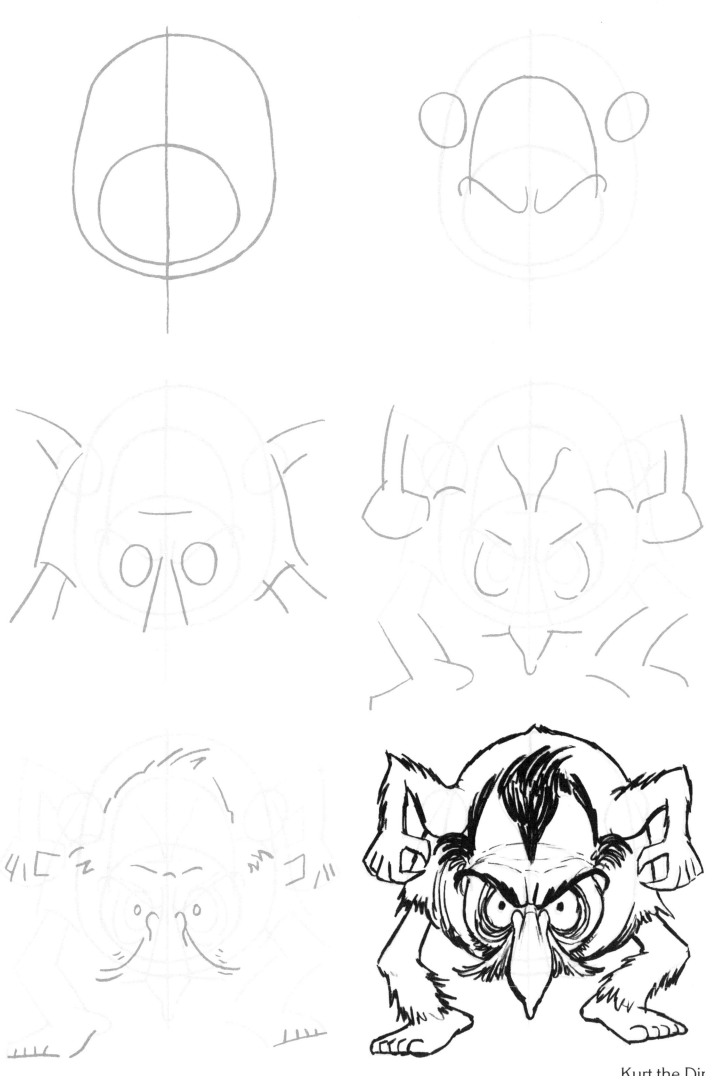

Kurt the Dirt

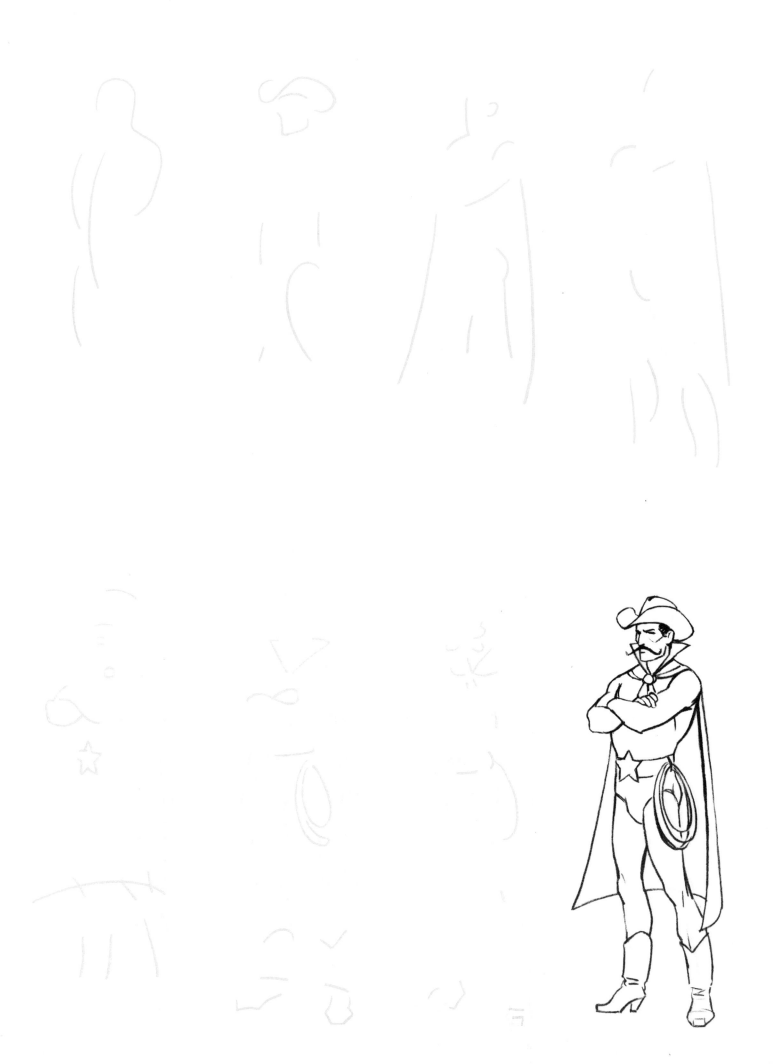

Super Cowboy

Lee J. Ames has been earning his living as an artist for almost forty years. He began his career working on Walt Disney's *Fantasia* and *Pinocchio*. He has taught at the School of Visual Arts in Manhattan and, more recently, at Dowling College on Long Island. He was, for a time, director of his own advertising agency and illustrator for several magazines. Mr. Ames has illustrated over one hundred books, from preschool picture books to postgraduate texts. When not working, he relaxes on the tennis court. A native New Yorker, Lee J. Ames lives in Dix Hills with his wife, Jocelyn, their three dogs, and a calico cat.

DRAW 50 FOR HOURS OF FUN!

Using Lee J. Ames's proven, step-by-step method of drawing instruction, you can easily learn to draw animals, monsters, airplanes, cars, sharks, buildings, dinosaurs, famous cartoons, and so much more! Millions of people have learned to draw by using the award-winning "Draw 50" technique. Now you can too!

COLLECT THE ENTIRE DRAW 50 SERIES!

The Draw 50 Series books are available from your local bookstore. You may also order direct (make a copy of this form to order). Titles are paperback, unless otherwise indicated.

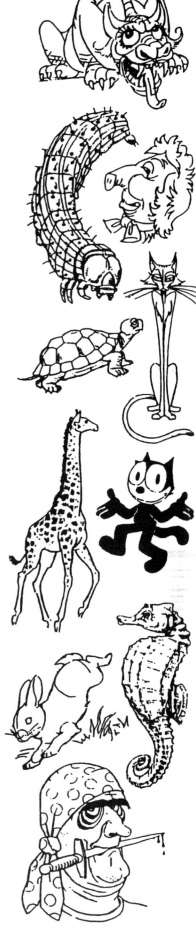

ISBN	TITLE	PRICE	QTY	TOTAL
23629-8	Airplanes, Aircraft, and Spacecraft	$9.99/$12.99 Can	× _____ =	_____
49145-X	Aliens	$9.99/$12.99 Can	× _____ =	_____
19519-2	Animals	$9.99/$12.99 Can	× _____ =	_____
90544-X	Animal 'Toons	$9.99/$12.99 Can	× _____ =	_____
24638-2	Athletes	$9.99/$12.99 Can	× _____ =	_____
26767-3	Beasties and Yugglies and Turnover Uglies and Things That Go Bump in the Night	$9.99/$12.99 Can	× _____ =	_____
47163-7	Birds	$9.99/$12.99 Can	× _____ =	_____
47006-1	Birds (hardcover)	$13.95/$18.95 Can	× _____ =	_____
23630-1	Boats, Ships, Trucks, and Trains	$9.99/$12.99 Can	× _____ =	_____
41777-2	Buildings and Other Structures	$9.99/$12.99 Can	× _____ =	_____
24639-0	Cars, Trucks, and Motorcycles	$9.99/$12.99 Can	× _____ =	_____
24640-4	Cats	$9.99/$12.99 Can	× _____ =	_____
42449-3	Creepy Crawlies	$9.99/$12.99 Can	× _____ =	_____
19520-6	Dinosaurs and Other Prehistoric Animals	$9.99/$12.99 Can	× _____ =	_____
23431-7	Dogs	$9.99/$12.99 Can	× _____ =	_____
46985-3	Endangered Animals	$9.99/$12.99 Can	× _____ =	_____
19521-4	Famous Cartoons	$9.99/$12.99 Can	× _____ =	_____
23432-5	Famous Faces	$9.99/$12.99 Can	× _____ =	_____
47150-5	Flowers, Trees, and Other Plants	$9.99/$12.99 Can	× _____ =	_____
26770-3	Holiday Decorations	$9.99/$12.99 Can	× _____ =	_____
17642-2	Horses	$9.99/$12.99 Can	× _____ =	_____
17639-2	Monsters	$9.99/$12.99 Can	× _____ =	_____
41194-4	People	$9.99/$12.99 Can	× _____ =	_____
47162-9	People of the Bible	$9.99/$12.99 Can	× _____ =	_____
47005-3	People of the Bible (hardcover)	$13.95/$19.95 Can	× _____ =	_____
26768-1	Sharks, Whales, and Other Sea Creatures	$9.99/$12.99 Can	× _____ =	_____
14154-8	Vehicles	$9.99/$12.99 Can	× _____ =	_____
	Shipping and handling	**(add $2.50 per order)** × _____ =		_____
		TOTAL		_____

Please send me the title(s) I have indicated above. I am enclosing $_____.

Send check or money order in U.S. funds only (no C.O.D.s or cash, please). Make check payable to Random House, Inc. Allow 4–6 weeks for delivery. Prices and availability subject to change without notice.

Name: _____

Address: _____ Apt. #_____

City: _____ State: _____ Zip: _____

Send completed coupon and payment to:

Random House, Inc.
Customer Service
400 Hahn Rd.
Westminster, MD 21157

BROADWAY